IMAGES
of America

CELEBRATING
CRANFORD

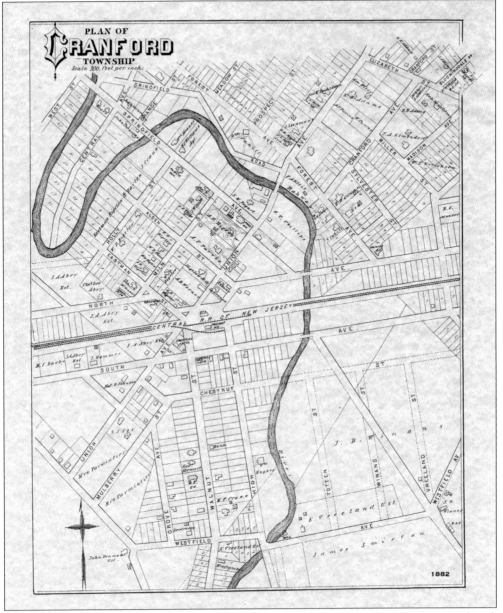

PLAN OF **CRANFORD** TOWNSHIP
Scale 300 feet per inch

1882

CRANFORD, 1882. About 11 years after it was incorporated, Cranford was still relatively undeveloped. Lots had been subdivided, but very few houses had been built. Names like Abry, Winans, Denman, Vreeland, and Cahill dominated the map, while Eastman, Bigelow & Dayton owned most of Holly Street. The Depression of 1873 was winding down, and recovery and development were about to begin. (Courtesy of the Cranford Historical Society.)

ON THE COVER: SKEETER CLUB, 1909. The Shanty Gang and the Lobster House were two of the many canoe clubs and liveries along the Rahway River in Cranford. Another, the Skeeter Canoe Club, was organized around 1904 by a group of Cranford boys. In 1908, they leased property near Central Avenue between Springfield Avenue and Eastman Street and built this clubhouse. They later reorganized as the Cranford Canoe Club. (Courtesy of the Cranford Historical Society.)

IMAGES
of America

CELEBRATING CRANFORD

Maureen E. Strazdon

ARCADIA
PUBLISHING

Copyright © 2021 by Maureen E. Strazdon
ISBN 978-1-4671-0704-4

Published by Arcadia Publishing
Charleston, South Carolina

Printed in the United States of America

Library of Congress Control Number: 2021935795

For all general information, please contact Arcadia Publishing:
Telephone 843-853-2070
Fax 843-853-0044
E-mail sales@arcadiapublishing.com
For customer service and orders:
Toll-Free 1-888-313-2665

Visit us on the Internet at www.arcadiapublishing.com

*To my husband, Victor Bary, without whose encouragement,
understanding, and support this book would not have been possible.*

CONTENTS

ACKNOWLEDGMENTS

Many people share credit for this book. Thanks to Victor Bary, curator of the Cranford Historical Society, whose knowledge of the society's archives was invaluable. The collection of the society provided most of the photographs I have included, and I thank them for that. Unless otherwise indicated, images are courtesy of the Cranford Historical Society. I am indebted to Bernie Wagenblast, a fellow history enthusiast who grew up in Cranford and who provided ideas, validation, and contacts. To the late Hazel and Arthur Burditt goes a world of thanks for compiling an index to Cranford newspapers that not only enabled me to find the articles I needed but also provided a running commentary on life in Cranford through the years. I extend very special thanks to the many friends and acquaintances, some old and some new, who spent so much time finding the perfect photograph. Finally, thanks to all the Cranfordites who took the images or who are pictured in this book for making Cranford what we celebrate today.

INTRODUCTION

Cranford's story can be traced back to the Unami tribe of the Lenni Lenape Nation, which occupied all of what is now known as New Jersey. Much later, in 1664, the Duke of York received a land grant, and English settlers moved into an area named the Elizabethtown Tract. Phillip Carteret and another group then arrived in early 1665 and established a colony they called Elizabethtown within the larger Elizabethtown Tract. Elizabethtown was officially chartered in 1693, and areas west of the Rahway River came to be referred to as the West Fields of Elizabethtown.

John Denman and John Crane were both early settlers of the West Fields, with Denman credited as being the first permanent white resident in the area in 1720. Denman established a farm in what is now the south side of Cranford, to the west of the Rahway River. Between 1716 and 1722, John Crane constructed a sawmill and a gristmill on the Rahway River, but he lived in Elizabethtown until 1724.

In the 18th century and into the 19th century, the area now sometimes called Crane's Mills remained an agricultural community, with wheat fields, fruit orchards, and sheep farming. Eleven mills were powered by the Rahway River.

There were no Revolutionary War battles fought in what would become Cranford. Troops were stationed in the area to alert George Washington at Morristown of any British movements from Staten Island, and Brig. Gen. William Irvine sent a letter to Washington on January 1, 1780, from what he called Crane's Mills. The grain ground in Cranford's mills supported General Washington's troops when they were in New Jersey.

In 1794, the West Fields, including Crane's Mills, split off from Elizabethtown and incorporated as Westfield.

In 1838, the Elizabeth-town & Somerville Rail-Road, the forerunner of the Jersey Central Railroad, was formed and ran two trains a day between the two towns, one in each direction. The train stopped in Crane's Mills at an empty field at French House, so named because it was near the home of a local resident originally from the French-speaking part of Switzerland.

But the story of Cranford really begins in 1864, when the Jersey Central Railroad completed a bridge across Newark Bay, providing a train link for New Yorkers arriving by ferry in Jersey City and making transit to and from New York much faster and easier. That same year, Jersey Central built a railroad station in Crane's Mills, which was now called Craneville. Those improvements piqued the interest of developers, who saw opportunities for homes for people who lived or worked in New York but wanted a summer residence in an area with cleaner air and a lovely setting like the Rahway River.

New Yorker Sylvester Cahill arrived before the bridge was built but saw potential, and between 1861 and 1867, he bought nearly 100 acres on the east side of the Rahway River in the area that was to become Cranford. Then, in 1864, Alden Bigelow, who was Sylvester Cahill's brother-in-law, Miln Dayton, and Albert Eastman of the New York firm Eastman, Bigelow & Dayton bought 37 acres of land. In 1865, the New Yorkers laid out streets which they named after themselves and

plotted lots in an area adjacent to the Rahway River, bounded by Springfield Avenue, North Union Avenue, Eastman Street, and Holly Street. The first home was constructed on the property in March 1865, and soon the men had built over 30 houses, with all but nine owned by Bigelow. Alden Bigelow built himself a mansion he called Marlborough Place in the middle of the plot on what is now Cleveland Plaza.

Then came the development of Central Avenue by Dr. Phineas P. Lounsberry, inventor of Dr. Lounsberry's Malt Extract, a patent medicine.

In 1869, the town adopted the name "Cranford," and in 1870, Sylvester Cahill, who had started selling or building on his land, successfully petitioned the state to incorporate Cranford as a township in its own right. On March 14, 1871, Cranford officially came into being.

Cranford developed rapidly. By its 25th anniversary in 1896, the town had grown and changed dramatically from what it had been in 1871. The population had doubled to over 2,000 by 1895. It was no longer a village of summer homes for wealthy New Yorkers but rather a town of permanent residents with stores, gas and later electric service, and more development to come.

In 1921, Cranford's 50th anniversary, the town was unrecognizable as the sleepy hamlet it had been in 1871 or even in 1896. A downtown with imposing buildings had sprung up, and more and more houses had been built farther from the railroad tracks. The Rahway River was no longer used for purely commercial purposes but was now the source of leisure activities as well.

In the 25 years between Cranford's 50th and 75th anniversaries, 1922 to 1946, the rapid construction of houses fostered Cranford's population increase to over 13,000. While Cranford's citizens suffered during the Depression and World War II, after the war, developers bought land and built neighborhoods, seemingly overnight. The south side of town particularly, which had continued to be the farmland it was back in the 18th century, was subdivided and new dwellings built.

Cranford celebrated its 100th anniversary in 1971 with a great deal of fanfare, including parades through town and activities in Nomahegan Park. The Rahway River, which had been used for celebrations for generations past, was no longer viable for the festivities, and so they were moved to Nomahegan Lake. And while the 25 postwar years of 1947 to 1971 saw less change in Cranford's physical landscape, the social landscape was changing as it was throughout the United States.

Between 1972 and 1996, the year Cranford saw its 125th anniversary, it celebrated the US Bicentennial and the Constitutional Bicentennial along with the rest of the country, as well as several local milestones. Cranford's population declined from a maximum of 27,000 and remained stable at around 23,000. With very little land available for new construction, the look of the town remained fairly constant.

Finally, the years from 1997 to 2021 brought Cranford to its 150th year of existence as a township. Internal and external events, like floods and terror attacks, impacted the lives of the citizens of Cranford. Older buildings were replaced by new, larger complexes. The Rahway River, for better or worse, continued to be the central and unifying feature of the town. And the citizens of Cranford remained united in their celebration of their town.

One

CELEBRATING CRANFORD'S BEGINNINGS 1871–1896

There is no record of a celebration held on March 14, 1896, to commemorate Cranford's first 25 years. Cranfordites went about their daily lives as on any other day. But in the 25 years between 1871 and 1896, there had been significant changes to the town. Summer retreats were giving way to year-round homes. The population went from 1,110 in 1875 to 2,145 in 1895. Despite some years of national economic issues, Cranford enjoyed a period of rapid progress.

Fifty gas streetlamps that had been ordered for North Avenue in 1872 were delivered in 1884. As houses were built, wooden sidewalks were put down. Gas service started, water pipes were laid, and electric lights were installed in homes. Fannie Bates and the Village Improvement Association lobbied for sanitary services, and sewer lines were installed. In 1888, Eugene Austin started development on 20 acres of land near North and Forest Avenues. The Presbyterian, Episcopal, Methodist, and Catholic churches were built during these 25 years.

The first river regatta, sponsored by the Cranford Boating Club, was held, as was the first river carnival, sponsored by the Cranford River Improvement Association.

In 1884, New Yorker J. Walter Thompson decided to improve the town. He commissioned local architect Frank T. Lent to design the Opera House Block at North Union Avenue and Eastman Street, and the building was completed in 1892, including a 500-seat auditorium, several stores, and the post office and library. Lent also designed the town's country club, the Cranford Casino, which was completed in October 1892. It soon became the social center for Cranford's elite.

The *Cranford Chronicle*, the town's first regular newspaper, was first published on November 29, 1893.

In 1894, Thompson announced his development of Roosevelt Manor, bounded by Orange Avenue, Willow (now Manor) Avenue, North Union Avenue, and Riverside Avenue (now Drive). He advertised "You buy the lot—we build the house," and Roosevelt Manor became the site of many of Cranford's most stately homes.

Cranford's first official 25 years ended in a burst of activity.

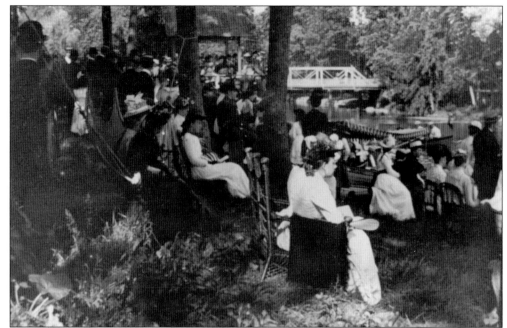

FIRST RIVER REGATTA, 1879. People line the banks of the Rahway River to watch the first river regatta, sponsored by the Cranford Boating Club and Association, in 1879. Regattas, unlike the later carnivals, were aquatic meets and consisted of swimming contests and boat races. Single and double scull, tandem canoe, and combination tub and swimming races were part of the event. Regattas continued for several years and later included musical performances.

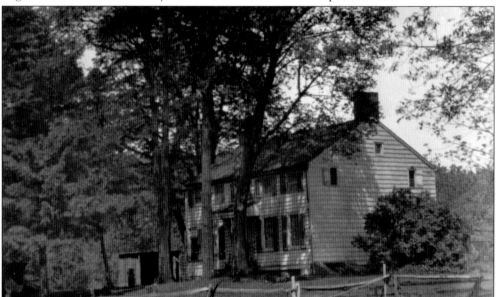

GARTHWAITE HOMESTEAD, 1880. The Garthwaites were early settlers of Cranford, establishing a homestead in the mid-1700s on the river around what is now Riverside Drive and Normandie Place. Edwin Garthwaite was one of the original members of the First Presbyterian Church, and in 1896 he sold part of his tract to the New Orange Industrial Association for the eventual creation of Kenilworth. This farmhouse, built around 1750, burned down around 1900.

LINCOLN AVENUE BRIDGE, C. 1885. This Lincoln Avenue or High Street bridge was constructed in the 1870s. Lincoln Avenue, also known at various times as Old York Road or Westfield Avenue, was one of the major roads linking New York and Philadelphia, so a bridge of some sort would have been there before that time. The intricate railing was replaced in the 1920s, and a new bridge was bult in 1997.

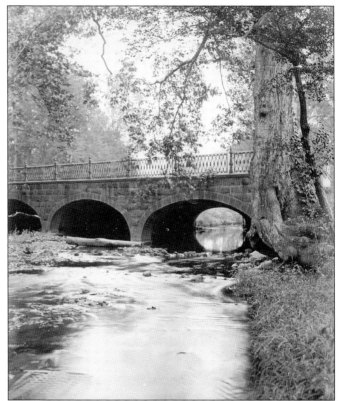

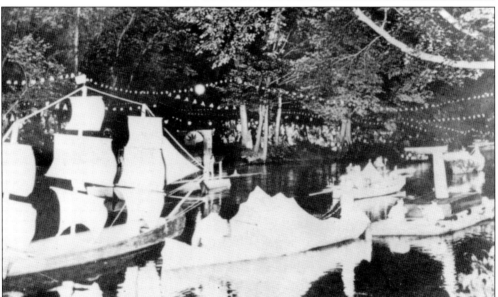

FIRST RIVER CARNIVAL, 1886. The first river carnival was held on August 1, 1886, organized by the newly formed Cranford River Improvement Association to focus on the beauty of the river and raise funds for cleanup of logs and household debris that had started to clog the Rahway River. This photograph, taken with an early version of a flash, shows some of the 25 decorated canoes that sailed up and down the river.

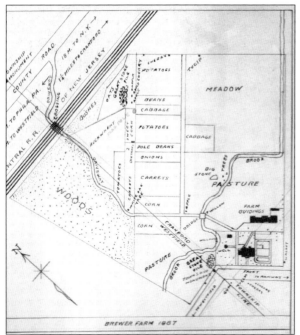

BREWER FARM, 1887. This plan from 1887 lays out the plantings on the Brewer acreage. The farm would now be in Garwood, since the western section of Cranford broke off in 1903 to incorporate as a separate town. The Brewer property appears on an 1870 map, and the 1870 US Census shows a family of 10 living on the farm, but how long they had been in Cranford is unclear.

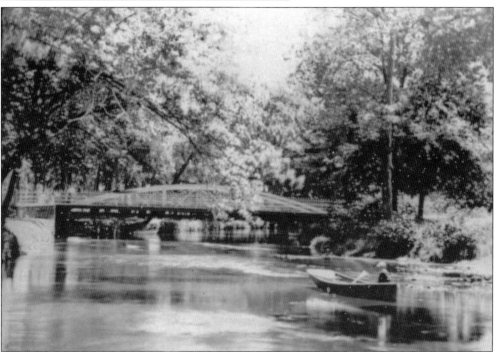

SECOND SPRINGFIELD AVENUE BRIDGE, C. 1888. Edward Beadle lived at the corner of West Street (later Hampton Street) and Springfield Avenue, and so the bridge over the Rahway River at that point, the second bridge over the river as people left town, was referred to as Beadle's Bridge. The first iron Beadle's Bridge, seen here in the distance, was replaced in 1914. Edward Beadle was the manager of the opera house, was on the township committee, and helped organize the first river carnival.

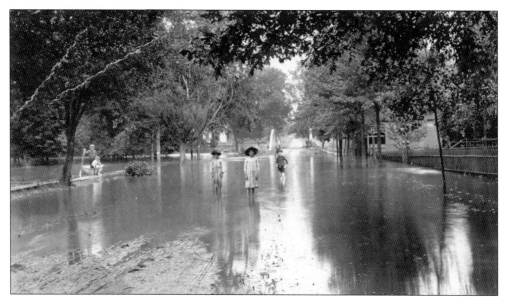

GREAT FLOOD, 1889. Three days of rain in July 1889 caused dams to burst, sending torrents of water through Cranford and towns upriver. Roads and houses were flooded as the Rahway overflowed its banks. Boats and their docks, and lumber in lumberyards, were swept away. Thirty of the 52 large bridges in Union County were destroyed. The Springfield Avenue or Beadle's Bridge can be seen partially submerged in the background of this photograph.

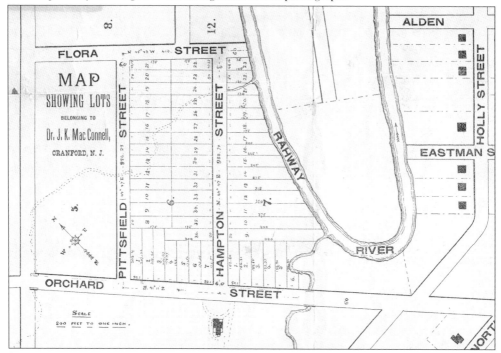

JOHN MACCONNELL PROPERTIES, 1887. John MacConnell moved to Cranford in 1869 and was the town's first physician. He bought and sold many properties, and this map shows some of the land he owned in 1887. The home he and his family lived in at Miln and Eastman Streets later became Hayashi's Restaurant and then in 1936 the site of the Cranford Post Office.

13

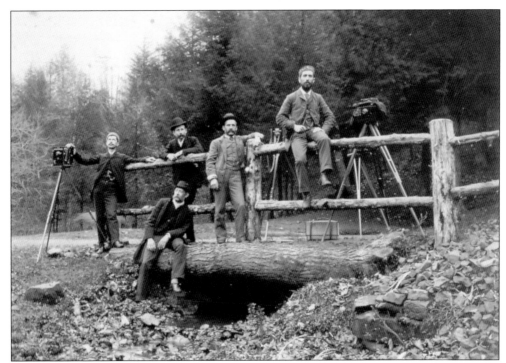

CAMERA CLUB, C. 1892. The Camera Club was established in the early 1890s, and in 1894 the *Cranford Chronicle* listed the Camera Club as meeting every Saturday evening. Glass photographic plates that had been used by both professional and amateur photographers since the 1850s were being phased out at about this time in favor of flexible plastic film. The case on the ground in the photograph appears to be one used for glass plates.

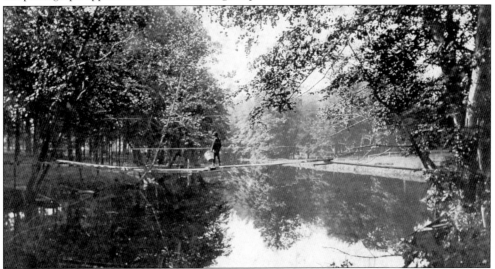

MOORE SUSPENSION BRIDGE, 1890. Before 1895, there was no bridge over the Rahway River at Eastman Street. However, there was a six-foot-wide suspended-cable footbridge that ran from the Moore property on Central Avenue to the foot of Alden Street. Tradition has it that the cables were manufactured by John A. Roebling's Sons Co., suppliers of cables for the Brooklyn Bridge. The bridge was removed when the Eastman Street bridge was completed.

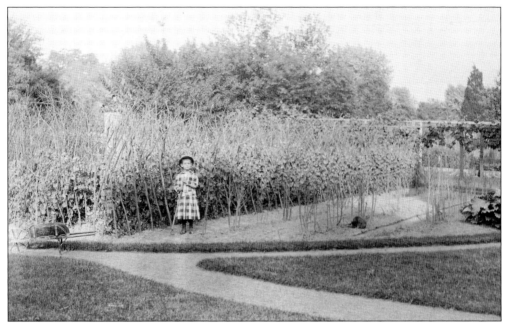

Billy Drysdale, 1891. Billy Drysdale was about five years old as he stood among vegetables at Marlborough Place, the estate owned by his grandfather Alden Bigelow. Marlborough was later the site of the Cleveland School and now Cleveland Plaza. Billy Drysdale was born in 1886 to William and Adelaide Bigelow Drysdale and died in 1915 at the age of 29. Note that up to the early 1900s, boys wore dresses as late as the age of eight.

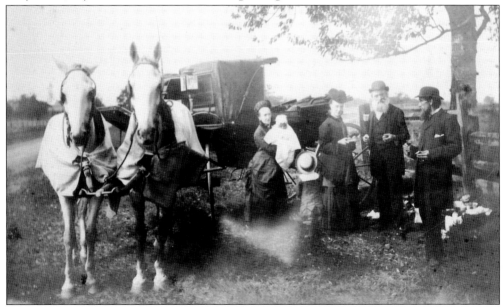

William Chamberlain Family, 1891. William Chamberlain, with the white beard, and unidentified members of his family have a picnic, perhaps not far from their home on North Avenue near Arlington Road. In 1894, Suburban Electric Company won a bid to electrify the town, and William Chamberlain became an electrician, advertising in 1895 that he was an agent of Suburban Electric and could wire a house and perform any electrical work.

CHARLES N. FOWLER, 1891. Charles Fowler lived in Cranford from 1883 to 1891, later moving to Elizabeth. He was a member of the US House of Representatives for the district covering Cranford from 1895 to 1911, and during his terms in office, he missed 58 percent of roll call votes, compared to 27 percent for the other representatives at the time.

GRANT SCHOOL, HIGH SCHOOL, C. 1894. Miss Foster's high school class was held in the first Grant School on Holly Street at Springfield Avenue, in use from 1870 to 1898. The wooden Victorian school served students in all grade levels from grammar through high school and in 1895 had a total of 305 students. About 15 students graduated from the high school in Cranford each year at the turn of the century.

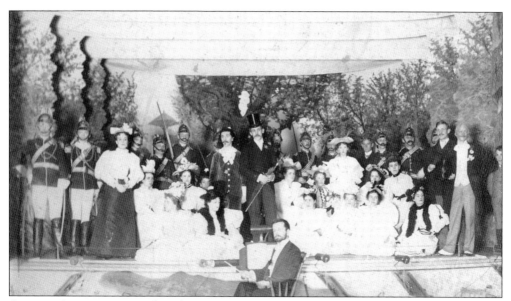

ALCAEUS SOCIETY, 1895. The Alcaeus Society was formed in 1892 as an amateur musical and operetta association. It presented three performances each year in the Opera House Block, frequently selling out the 500-seat theater. Here, the 30-member troupe presents *Patience* by Gilbert and Sullivan in 1895.

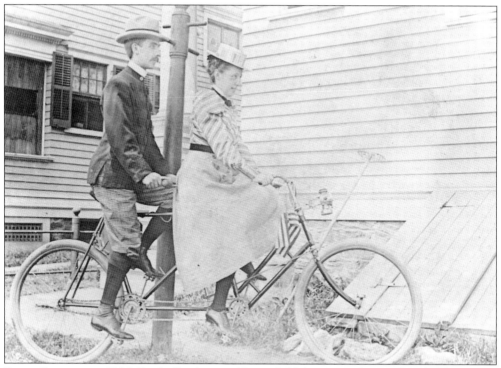

EMILIE SANDERSON, 1892. Emilie Sanderson of Springfield Avenue and an unidentified friend take a ride on a tandem bicycle. Around 1890, when the Cranford Cycling Club was formed, bicycles were a craze in Cranford, and tandems became popular a little later. This photograph was taken a few years before bloomers became the standard dress for women cyclists.

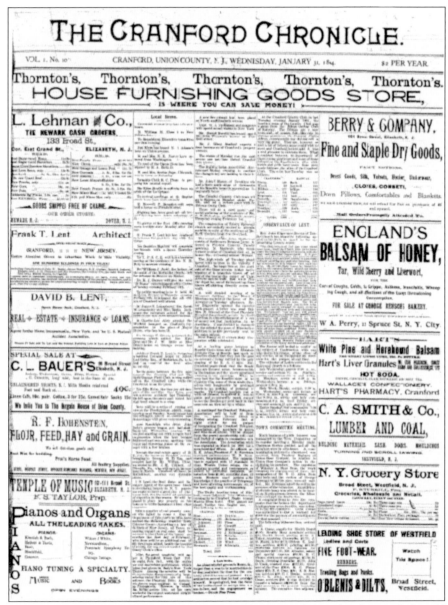

CRANFORD CHRONICLE, 1893. In the 1870s, Cranford had several short-lived, irregularly published newspapers, including the *Cranford Times*, *Cranford Comet*, and the *Courier*. The initial issue of the town's first regular paper, the *Cranford Chronicle*, was published on November 29, 1893, by John Potter. It consisted of four pages of advertisements, serial stories, and a bit of Cranford news. Copies of the weekly paper were printed in Manhattan, but printing was moved to the Potter-Chronicle Building at North and North Union Avenues in 1897. A competing paper, the *Cranford Citizen*, was started in 1898 by James Warner, and in 1921 he merged the two papers, changing the name to the *Cranford Citizen and Chronicle*. In 1952, Charles Ray took full ownership and printed the paper at 21 Alden Street. He sold the paper in 1971, printing was moved out of Cranford, and the name changed back to the *Cranford Chronicle*. The Potter-Chronicle Building was torn down in 1926 and is now the site of Eastman Plaza. The *Cranford Chronicle* published its last edition in June 2015. (Courtesy of the Cranford Public Library.)

RICHARD CLEMENT, 1895. Richard Clement served as supervising principal of the Cranford public schools for 14 years while teaching civics, chemistry, and higher mathematics. He was described as a tall man with a walrus moustache and long hair who looked a bit like Abraham Lincoln. After leaving Cranford in 1900, he became a principal and then superintendent of schools in Elizabeth.

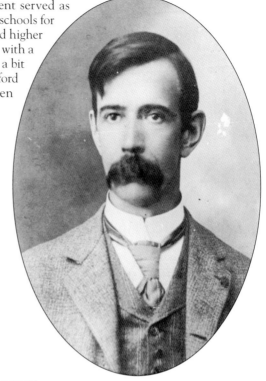

RATH BUILDING, C. 1895. In 1894, Harry Rath, a plumber doing business from the Miller Building, erected this building at North and North Union Avenues, installing stone sidewalks in front of it. The building was designed by local architect Frank T. Lent, and it housed stores and offices. At the time, the building stood alone, but it would soon be joined by other businesses as the town grew.

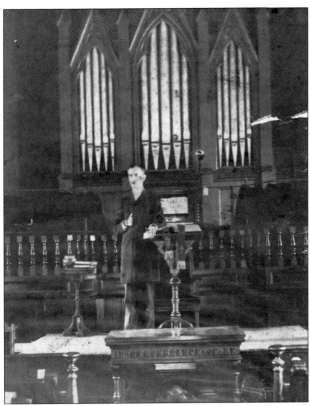

Rev. Dr. George Greene, 1895. Rev. Dr. George Greene served as pastor of the First Presbyterian Church on Springfield and North Union Avenues from 1885 to 1925. During his tenure, membership grew from 125 to 626, and in 1894 the current church was built. The organ Dr. Greene stands in front of was installed when the church was constructed, but after his death in 1926, a new organ was dedicated to him.

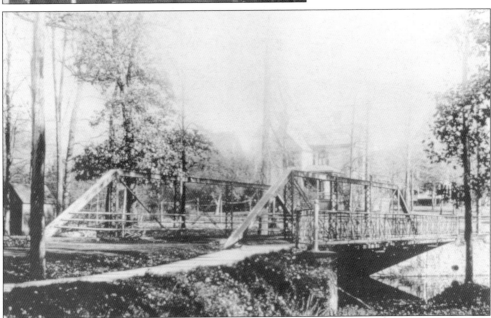

Eastman Street Bridge, c. 1896. The first Eastman Street bridge was built in 1895. Before that time, the Springfield Avenue bridge was the only way to get a cart or carriage over the river in that part of town. The first bridge was replaced in 1917. Houses on Holly Street can be seen in the background of this photograph.

BILLY DRYSDALE AND WALTER CRANE, 1896. Ten-year-old Billy Drysdale (left) and eight-year-old Walter Crane (right) get ready to launch a boat at the foot of Alden Street. Billy Drysdale was the son of author William Drysdale, and Walter Crane was the son of grocer John M. Crane. Both boys lived on Miln Street.

ROSE VILLA MUSIC SOCIETY, C. 1896. Ethel Young Thompson founded the Rose Villa Music Society around 1895. She was a graduate of the New York Conservatory of Music and served as president from the group's founding until her death in 1944. The 25 women members met every two weeks from October to June at Rose Villa, the Thompson home on Pittsfield Street, and presented themed musical programs.

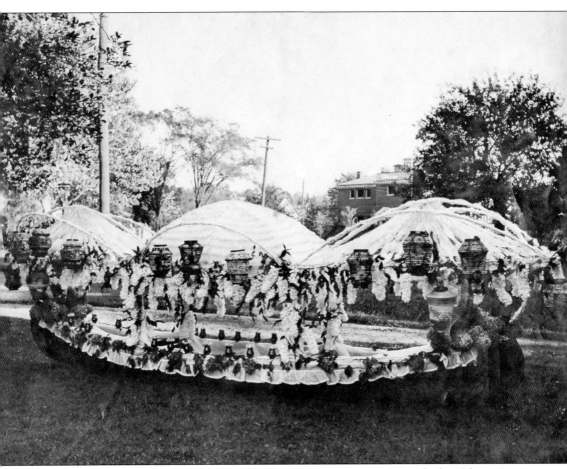

CRANFORD'S 25TH ANNIVERSARY, 1896. There is no mention of Cranford's 25th anniversary in the *Cranford Chronicle* in 1896, nor is there any reference to celebrations for the milestone. There was a very short article in the *Elizabeth Daily Journal* on March 14, 1896, that noted that Cranford had been incorporated on that day 25 years earlier. It listed the town's 1871 officials, with Alden Bigelow as the first freeholder and Moses Crane as the first tax collector, but there was no discussion of festivities in that article either. Cranford did hold its 11th Venetian Carnival on August 22 with 70 beautifully adorned floats and canoes like this one, music, lawn decorations, fireworks, and Chinese and Japanese lanterns. The announcement of the carnival anticipated that 20,000 people would attend, but reports estimated the number closer to 8,000. One report likened it to a fairyland with colored lights on lawns in the moonlight.

Two

Celebrating Cranford's Growth 1897–1921

When Cranford celebrated its 50th anniversary with a river parade and Mardi Gras in July 1921, the population was just over 6,000, a threefold increase in 25 years. Growth was continuing at a significant pace despite Kenilworth and Garwood breaking away and forming their own towns.

The trolley power station was built in 1903 to run the new mode of public transportation, the trolley car. Street signs were installed, and in 1907 a portion of Springfield Avenue was paved, expanding it from a single-lane dirt road. During those years, fire hydrants were placed around town, and a new firehouse was built on North Avenue. The Cranford Casino burned to the ground but was soon rebuilt on the same site. The impressive Opera House Block burned, but it was replaced within a year by the equally impressive Cranford Trust Building. The second Grant School was built, as were the Sherman, Cleveland, and Lincoln Schools. Communications improved as telephones were installed in private homes and free mail delivery began. The public library that had been established in 1895 moved to Miln Street in 1910. The Baptist and African Methodist Episcopal churches were built.

The women of Cranford were applauded in an article in the *San Francisco Call*, and Cranford's Alice Lakey succeeded in getting national pure food legislation passed.

The citizens of Cranford enthusiastically supported calls for volunteers and World War I bond purchases, raising three times more than the pledged bond amount, as they established a home guard to defend the town.

The Rahway River was now so popular that Cranford was known as the "Venice of New Jersey." The annual summer river carnivals drew thousands of people to line the banks of the river and admire the ornately decorated floats.

Cranford continued to grow in neighborhoods such as Balmiere Park on the north side and Lincoln Park on the south side of town. Some were advertised for the well-to-do, others for the average citizen. The footprint of the town expanded significantly.

In 1921, the people of Cranford were ready to celebrate their golden anniversary and the end of World War I and the Spanish flu pandemic.

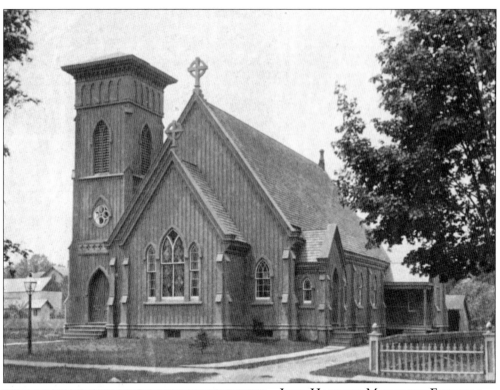

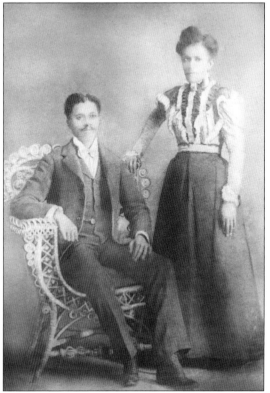

JOHN HANCOCK METHODIST EPISCOPAL CHURCH, C. 1898. The first Methodist chapel was built in 1863 on Westfield (now Lincoln) Avenue near the railroad. In 1871, the congregation moved into this larger church on Walnut Avenue, which served it for over 80 years. In 1954, the present United Methodist church was constructed less than a block away at Walnut and Lincoln Avenues. The old 1871 building was razed in 1961 and replaced by the Cranford Public Library.

DAVID AND CLAUDIA PARROTT EPPS, C. 1900. David Epps and his wife, Claudia Parrott Epps, came to Cranford in about 1900; this photograph was taken in Macon, Georgia, before they migrated north. David Epps opened a restaurant in 1907 and later delivered oil and gasoline. He was elected assistant treasurer of the Cranford Colored Political Club in 1911.

CARLTON B. PIERCE, C. 1902.
Carlton B. Pierce came to Cranford in 1893 and was one of the first lawyers in town. He lived on Prospect Avenue until shortly before his death in 1927. He was a Union County judge and also served in the state senate and assembly. He was best known for his fight for legislation to remove railroad crossings at street levels throughout the state.

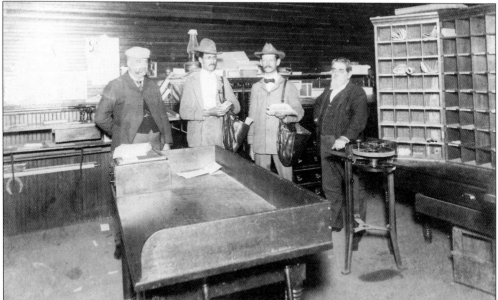

POST OFFICE, 1900. From left to right, postmaster John Derby, letter carriers Harry Crane and Walter Reinhart, and assistant postmaster John Crane stand in the post office in the Opera House Block. The post office moved several times, including to the building at North Union Avenue and Alden Street that still says "Post Office" at the cornice. The post office moved to its present site in 1936.

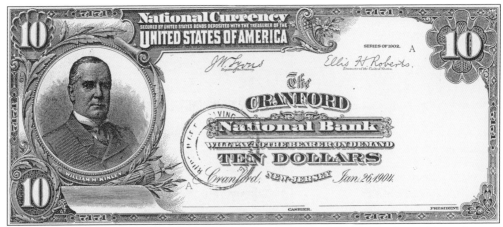

CRANFORD NATIONAL BANK, 1904. The Cranford National Bank, established in 1904, was located in the Masonic Building on North Union Avenue. From 1863 to 1935, local banks with federal charters could issue currency like this backed by the federal government, and from 1904 to 1912, Cranford National Bank issued $138,300 in $10 and $20 bills, each of which was three by eight inches in size. (Courtesy of Robert Kotcher.)

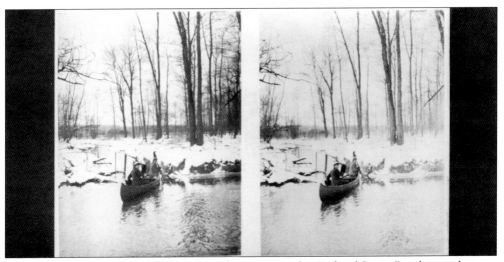

RIVER IN WINTER, C. 1906. Two boys launch a canoe on the Orchard Street Brook in midwinter. The picture was meant to be used in a stereoscope, a device popular from the 1850s to the 1930s that gave an image a three-dimensional effect. In 1861, Oliver Wendell Holmes created a handheld device that was more economical than earlier models and thereby increased the popularity of stereoscopes as entertainment.

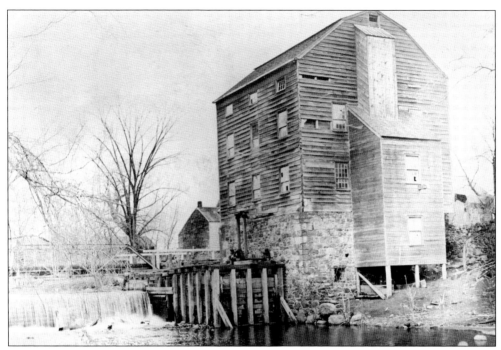

VREELAND'S MILL, 1908. The Vreelands owned at least two of the 11 mills on the Rahway River, this one close to Raritan Road near Centennial Avenue. This gristmill was built in the 1700s and remodeled in about 1912 by Thomas Sperry to serve as the pumphouse on his Osceola Farm. It was demolished to make way for the Garden State Parkway.

CRANFORD ILLUSTRATED. 101

✠✠✠ Fairview Cemetery, ✠✠✠

Incorporated January 13, 1868. Westfield, New Jersey.

From its central location, accessibility, beautiful surroundings and the wide and almost unrivaled views from its summit, commanding the country for miles around in every direction, it is the most charming site for a rural cemetery in the vicinity of New York or in the State of New Jersey.

This cemetery is not a speculative institution, but is held in perpetuity by a board of trustees, elected by the lot owners annually, the proceeds from the sale of lots being used exclusively for beautifying and improving the grounds. Every purchaser of a lot, therefore, has a voice in its management.

This cemetery comprises nearly 75 acres of ground, and has desirable lots to sell at reasonable prices. INSPECTION IS INVITED.

JOHN S. IRVING, *President.* JAMES T. PIERSON, *Vice-President.*
 CHARLES C. DILTS, *Secretary.* GEORGE H. EMBRE, *Treasurer.*
Telephone. 65 A, Westfield. C. W. SORTOR, *Superintendent.*

FAIRVIEW CEMETERY, 1904. Fairview Cemetery has been the final resting place for many Cranfordites of all colors and all social classes since its dedication in 1868. It is located between Cranford and Westfield on land purchased from the Millers and the Piersons. The cemetery and other businesses placed advertisements in the 1904 *Cranford Illustrated*, a brochure published by Louie Hendrickson about the advantages of living in Cranford.

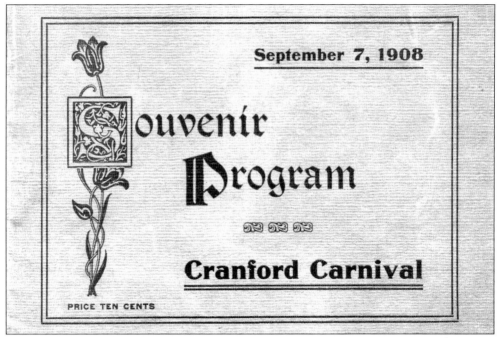

September 7, 1908

Souvenir Program

Cranford Carnival

PRICE TEN CENTS

RIVER CARNIVAL PROGRAM, 1908. By 1908, the opening of events to people from other towns and the construction of the Cranford Casino had made the Rahway River carnivals more popular. The 1908 carnival was one of the most spectacular, with 100 decorated canoes moving from the North Union Avenue dam to Hampton Hall, now Hampton Park, and back again. Lawns and houses along the route were decorated with lanterns and flags.

NORTH UNION AVENUE BRIDGE, c. 1909. The roadway leading up to the North Union Avenue bridge, which can be seen in the distance, had been paved with macadam in 1901. The original wooden bridge was replaced sometime before 1905 by this iron structure thanks to the efforts of Union County freeholder John Isenmann.

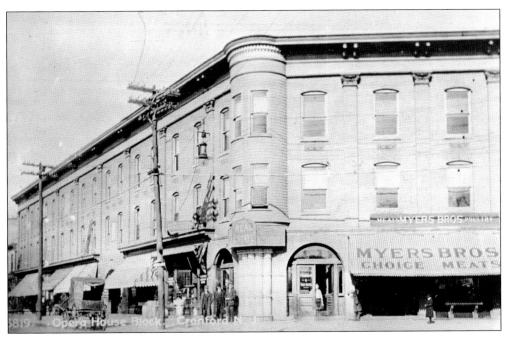

OPERA HOUSE BLOCK AND TICKET, 1909 AND 1912. The Opera House Block was completed in 1892 at the corner of North Union Avenue and Eastman Street. It was designed by local architect Frank T. Lent and was financed by J. Walter Thompson on property purchased from James Ferguson. The building housed the post office, the library, meeting rooms, and a 500-seat auditorium with a large stage. The auditorium was on the third floor and was used for musical and vaudeville programs, commencements, lectures, and public meetings. This ticket was for a mask and civil ball, which was probably the last event held before the entire block burned to the ground in a spectacular fire on February 3, 1912. The Opera House Block was replaced by the Cranford Trust Building.

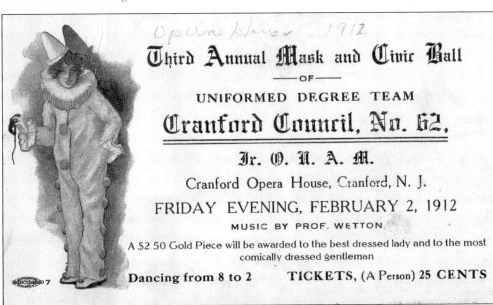

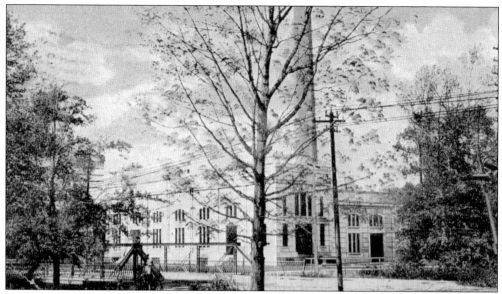

TROLLEY POWER STATION, 1910. When it was built in 1903 on South Avenue near Centennial Avenue, this station supplied power for trolleys. It later provided electric light current to supplement what was brought from Elizabeth. As of 1928, it supplied power for all of Cranford. The station was flooded by Hurricane Irene in 2011, and it was demolished in 2016 to allow for elevation of the equipment above flood level.

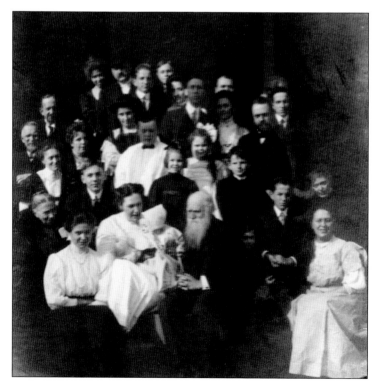

BENJAMIN FRANKLIN HAM, 1910. Benjamin Ham, born in 1836, was surrounded by his family shortly before his death. He was one of the wealthiest men in town, owning real estate and a seat on the New York Stock Exchange. He held several township positions and was active in the Methodist church, saving it from eviction in the 1880s. In 1895, he created a map that established property lines in town.

JOHN MOODY, 1910. John Moody lived in Cranford from 1893 until 1913, first on Miln Street, then after his marriage on Prospect Avenue. In 1900, he began publishing manuals that analyzed investments, ultimately expanding to *Moody's Investors Service*, which still provides financial research and ratings on bonds issued by companies and governments. He was born in 1868 and died in 1958 at the age of 89.

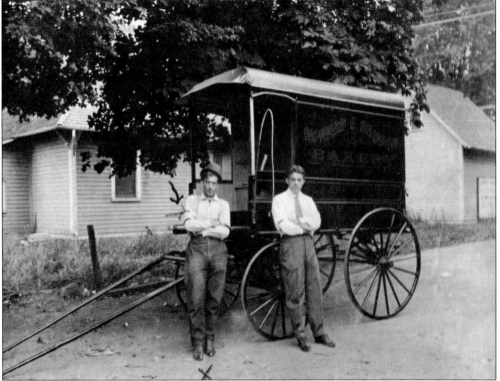

RAUSCH BAKERY, 1911. Edward Rausch (left) and Frank Sanders (right) stand next to the Howard E. Rausch bakery delivery wagon. The business was started by George Rausch in 1878, and it was managed at different times by his two sons, Edward Rausch and Howard Rausch. Located on Eastman Street, the bakery supplied goods to surrounding towns as well as Cranford. Edward Rausch was the manager from 1918 until it closed in 1946.

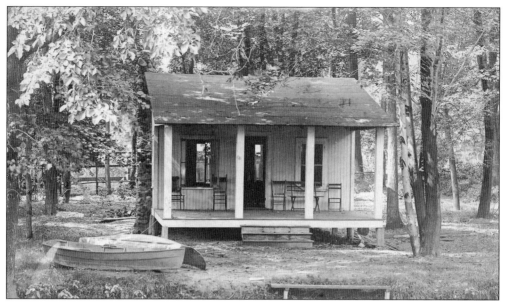

FIELD AND RIVER CLUB, 1911. The Field and River Club was built by a group of boys around 1910 behind the Hopkins house on Springfield Avenue. Twenty-two of the 30 club members served in World War I, so the club didn't meet during that time. The building burned, and only the chimney and fireplace that can be seen on the left side of the house in the photograph remain in what is now Hanson Park.

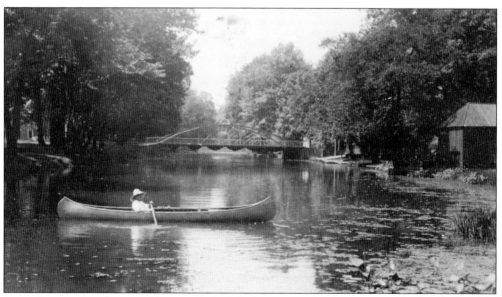

FIRST SPRINGFIELD AVENUE BRIDGE, 1912. John Isenmann lived next to the bridge that can be seen in the distance at Orange and Springfield Avenues. It was the first bridge over the Rahway River as people left town and was known as Isenmann's Bridge. John Isenmann was a Union County freeholder and lobbied for funding for bridges in Cranford, succeeding in replacing six wooden bridges with iron ones, this one, the first, in 1878.

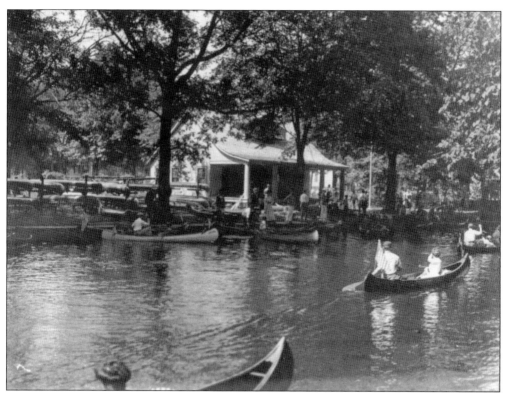

CRANFORD CANOE CLUB, C. 1912. In 1910, members of the Cranford Canoe Club built a clubhouse on the Rahway River west of Springfield Avenue. A dock extended from the porch to the riverbank for launching canoes. In 1934, the Cranford Canoe Club members moved across the street to the old Ulhigh clubhouse and began renting their former clubhouse to the Girl Scouts. The Little House, as it was known, was demolished in 1964.

SOUTH AVENUE TROLLEY TRACKS, 1913. Electrically powered trolleys started running through Cranford in 1899 and became the main source of public transportation. When service began, it went from Elizabeth to Plainfield over tracks on South Avenue. The tracks passed next to the power plant near Centennial Avenue, seen on the right, built in 1903 to provide electricity for the trolleys. Public Service Trolley No. 49 made its last run in 1935.

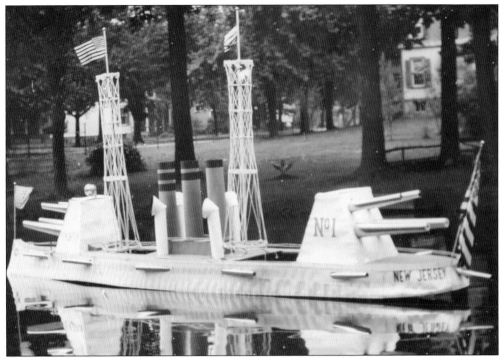

RIVER CARNIVAL FLOAT, 1914. Over 8,000 people had attended the 1896 river carnival, and because of the growing popularity of the carnival since its beginnings in 1886, Cranford had become known as the "Venice of New Jersey." Over the years, the lanterns and flower decorations of earlier carnival canoes gave way to more complex and topical themes, such as this 1914 entry, the battleship *New Jersey*.

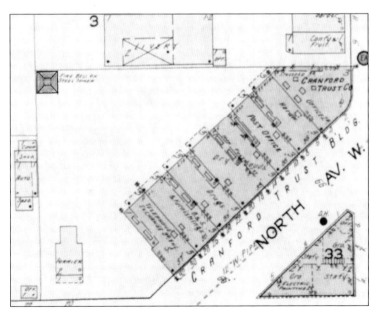

FIRE BELL TOWER, 1915. Early firefighters were summoned by the Presbyterian church bell, then by a bell in a tower behind the Opera House Block. In late 1915, the bell was relocated to a new 25-foot tower closer to the new firehouse, its location shown as a box in the upper left corner of this map. In 1926, the tower was dismantled, having been replaced by a siren. (Courtesy of Sanborn Fire Insurance Maps.)

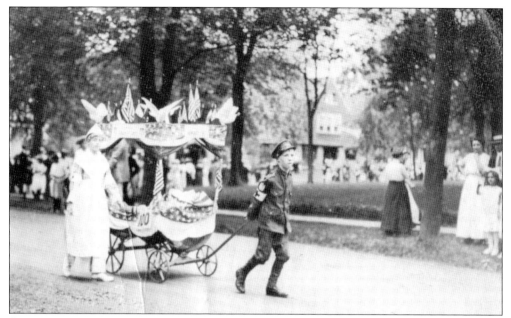

CHILDREN'S CARNIVAL, 1915. In place of the annual river carnival, Cranford held a children's carnival on July 5, 1915. Twenty prizes were awarded for the best decorated of the 150 doll carriages, floats, baby carriages, wagons such as this one, and bicycles that paraded through town. Queen Gertrude Loveland, who had been selected by votes that could be purchased for one cent each, led the parade and later presented loving cups to the winners.

GRANT SCHOOL, FIRST GRADE, 1917. In 1899, a new brick Grant School was constructed on the site on Holly Street at Springfield Avenue of the original Grant School, which had been built in 1870. The cost of the new school was $24,700. In 1899, enrollment was 569 students, and by 1915, that number was 943. This Grant School was used as a public school until 1936 and was razed in the 1960s.

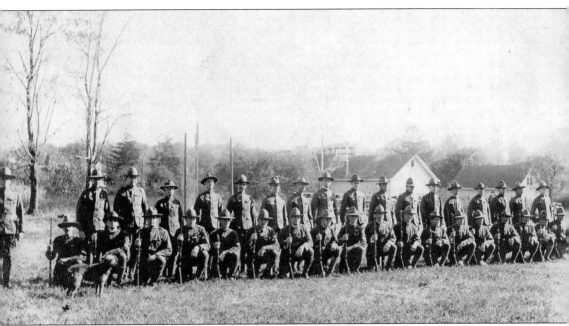

PATRIOTIC CRANFORD, 1917. As the United States entered World War I in 1917, Cranford rallied in support of the effort. Nearly 200 residents signed up for the Cranford home guard when it was established in March 1917 to protect the town. Nighttime patrolling was started but abandoned in favor of drilling, as can be seen here, and supporting patriotic events. In June, the Red Cross chapter was escorted by the home guard to its new headquarters in the Cranford Trust Building, followed by a rally to raise funds. Also that month, Cranford joined other Union County communities in holding a daylong registration event that included a parade to honor the 465 Cranford men who were registering for the draft. Headed by a band, members of church clubs, civic organizations, the fire and police departments, schoolchildren, and the home guard marched past decorated houses and stores and people waving American flags. In September there was a parade to send off the men who had been drafted, and in October there was a Liberty Day parade.

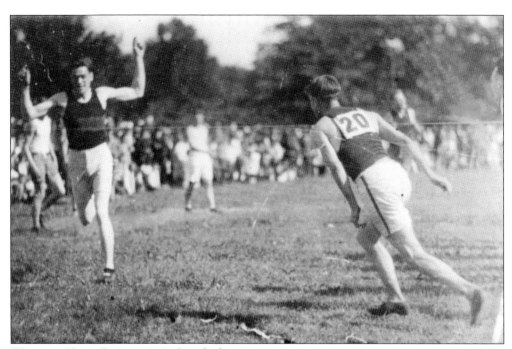

WELCOME HOME EVENT, 1919. Cranford held a daylong program on September 13 to honor the Cranfordites returning from World War I. Over 5,000 people attended events that included athletic contests among the veterans, as seen here, a program featuring an address by New Jersey's governor, and dancing at North Union Avenue. Medals were presented to all the veterans who attended a dinner in their honor.

WADE HAMPTON HAYES, C. 1919. Brig. Gen. Wade Hampton Hayes was born in 1879 and lived on Pittsfield Street with his wife, Julia Hayes, from 1905 to 1939. He served in the Spanish-American War and during World War I was on Gen. John Pershing's staff in France. In World War II, he was a member of an American unit protecting members of the British government.

Avoid Telephoning During the Epidemic

The prevalence of SPANISH INFLUENZA among our operating forces, makes it necessary that we continue our appeal — DON'T MAKE UN-NECESSARY TELEPHONE CALLS.

The situation still remains very serious, and in certain sections it is necessary for us to ask calling parties if their calls are necessary before connections are made.

DURING THE EPIDEMIC will you please confine your telephoning to indispensible calling, such as —

1. Calls occasioned by fire, lawlessness, accident, death, or serious illness.
2. Calls to and from hospitals, doctors, druggists, etc.
3. Calls necessitated by the public interest and welfare or by Government business and war work.
4. Commercial calls of vital importance.

MAKE ONLY CALLS THAT CANNOT BE AVOIDED.

EPIDEMIC, 1918. In October 1918, the Spanish flu was first mentioned in Cranford newspapers, reporting the town's first fatality. For three weeks that October, all public gatherings were banned. Cranford lost six citizens, all but one in the military. With an operator shortage, the New York Telephone Company ran an advertisement in the *Cranford Citizen* on November 14, 1918, asking all 1,000 residents owning telephones to restrict calls. (Courtesy of the Cranford Public Library.)

CRANFORD PBA, 1921. The Cranford Police Benevolent Association was formed in 1921. The first officers of the organization were, from left to right, (first row) Vice Pres. Patrick Martin, Pres. James Manning, and Secretary Lawrence Bonnell Sr.; (second row) Sgt. at Arms Edward Schlindler and Treasurer Antonio Colineri.

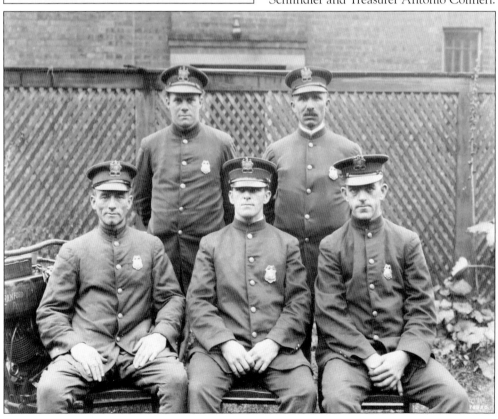

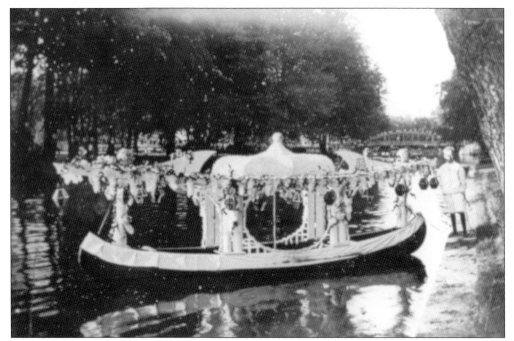

RIVER CARNIVAL FLOAT, 1920. While the new bridges that were being constructed along the Rahway River made creating the floats more difficult, the floats continued to be impressive, like this award-winning one from the 1920 carnival. The World War I years had somewhat diminished the event, but prizes continued to be awarded for the floats as well as decorations in yards along the riverbank.

CLEVELAND SCHOOL, C. 1921. Alden Bigelow's estate on Miln Street was purchased by the township in 1913 for the construction of the Cleveland School, named for former president Grover Cleveland. It was originally a combined grade and high school but was an elementary school from 1938 to 1974, after upper grades moved to the new high school. In 1981, it was converted to an office building, Cleveland Plaza.

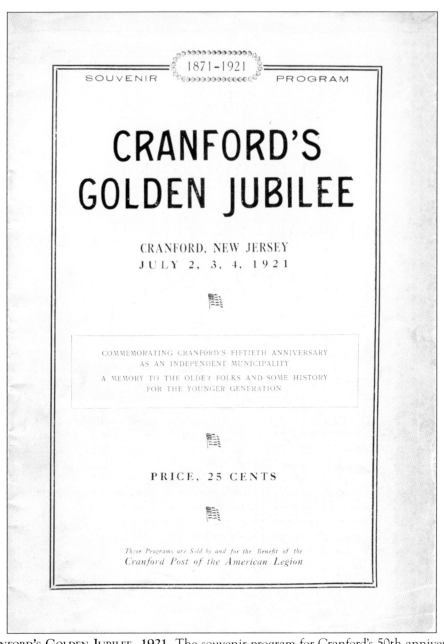

1871-1921

SOUVENIR PROGRAM

CRANFORD'S GOLDEN JUBILEE

CRANFORD, NEW JERSEY
JULY 2, 3, 4, 1921

COMMEMORATING CRANFORD'S FIFTIETH ANNIVERSARY
AS AN INDEPENDENT MUNICIPALITY

A MEMORY TO THE OLDER FOLKS AND SOME HISTORY
FOR THE YOUNGER GENERATION

PRICE, 25 CENTS

These Programs are Sold by and for the Benefit of the
Cranford Post of the American Legion

CRANFORD'S GOLDEN JUBILEE, 1921. The souvenir program for Cranford's 50th anniversary celebration listed three days of events on July 2, 3, and 4, 1921. The program detailed festivities marking the semicentennial, including a baseball game, a Mardi Gras parade, a block dance on North Union Avenue, a pageant on the Cleveland School grounds, historical exhibits, and a river carnival. The executive committee for the jubilee was made up of over 100 of Cranford's leading citizens. People came from Cranford and neighboring towns to see the river carnival floats entered by local organizations and individuals and the parade, which included a kazoo band. The baseball game between the Veterans of Foreign Wars and the American Legion was won by the Veterans of Foreign Wars. Prizes were given for floats and canoes, best decorated houses, lawns, and stores. The *Elizabeth Daily Journal* reported that it was a memorable day.

Three

CELEBRATING CRANFORD'S RESILIENCE 1922–1946

Cranford's 75th anniversary activities in 1946 were subdued compared to the other celebrations that year welcoming soldiers back from fighting in World War II. The Depression and the war had been difficult for Cranford's citizens, but progress continued. From 1920 to 1940, the population had doubled again to almost 13,000.

The Cranford Theater, initially the Branford, showed its first movie in 1926. Stores and restaurants opened downtown. In 1929, the horizontal street signs that had been installed in 1906 were replaced by concrete pillars with vertical ceramic tiles. The train tracks that had been the site of numerous accidents were elevated from street level and a new station built. The Lutheran church and a synagogue were constructed. Meanwhile, busses were replacing trolley cars. Some of Cranford's women went off to war, while others went to work.

The Depression also brought the Work Projects Administration (WPA). The post office and the high school were built, and Lenape Park Lake and Nomahegan Park were created through that program. The mural in the post office and those painted for the high school and now in the Municipal Building were funded through the Treasury Department's Section of Painting and Sculpture, a WPA program.

Cranford's largest development, Sunny Acres, was built. Osceola Park, Unami Park View, Columbia Manor, and Heathermeade Hills also added to the housing stock.

As the population expanded, schools were built. The high school and Roosevelt and St. Michael's Schools were constructed, as well as an addition to the Lincoln School. Union Junior College took over the Grant School on Holly Street in 1942. In 1945, the little red schoolhouse that had initially served Cranford students was demolished.

During the World War II years, citizens of Cranford joined much of the United States in experiencing blackouts, air raid drills, and rationing. There were events to send off volunteers and draftees and to sell war bonds.

As those sometimes difficult 25 years drew to a close in 1946, Cranford was ready for celebration.

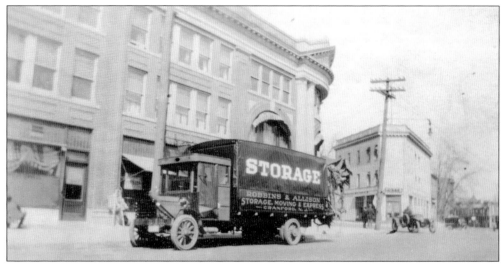

ROBBINS AND ALLISON MOVING AND STORAGE, C. 1923. Robbins and Allison was started by cousins George Robbins Jr. and Louis Robbins Allison in 1913 as a trucking company. They grew their business to include furniture sales as well as storage and moving, using distinctive orange vans. George Robbins died in 1923, Louis Allison died 1962, and the business was sold in 1964. Their warehouse on South Avenue was demolished and the Spencer Savings Bank was built in 2003.

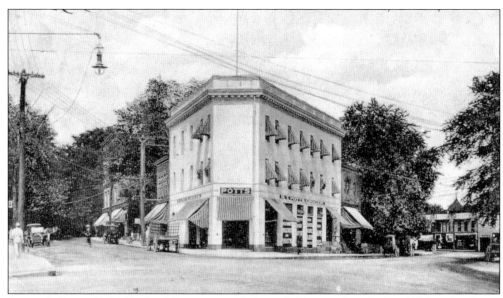

POTTS & SONS, 1924. Richard Potts opened J. Potts & Sons in Cranford in 1895 in the Opera House Block. He bought the Rath Building in 1903, and in 1907 he built a new three-story structure on the site at North and North Union Avenues. Nelson Tremble was the manager of the store that sold imported and "fancy" food. The store closed in 1924, but the building remains and has housed several banks.

JAMES W. FERGUSON, 1924. James Ferguson came to Cranford in 1878, ultimately residing in Roosevelt Manor. He was a partner in Ferguson and Van Name, an insurance and real estate business, as well as a large property owner. He was also a member of the Board of Education and the president of the Cranford Mutual Building and Loan Association for 30 years until his death in 1926.

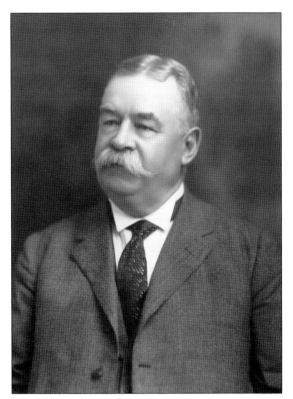

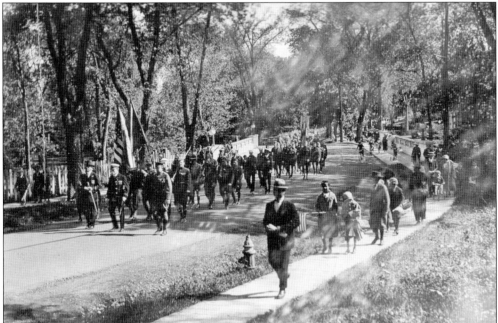

DECORATION DAY PARADE, 1924. Harvey N. Fiske leads a group of military officers in the 1924 Decoration Day parade. Every year on the last Monday of May, a Memorial Day parade, as it is now called, winds through town to Memorial Park, where Cranford residents who served, died, or were wounded in the service of their country are recognized.

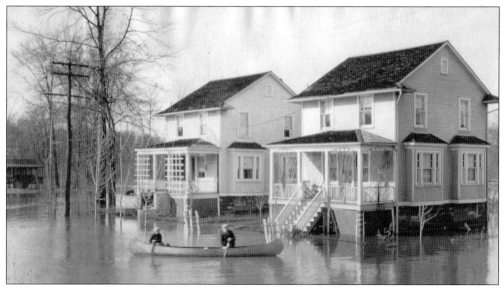

Edgar Avenue Flood, 1924. Heavy rain on April 7 resulted in flooding all through town, including Edgar Avenue near Nomahegan Park, Centennial Avenue, and Sperry Park. Basements and streets were flooded, requiring boats rather than cars to get around.

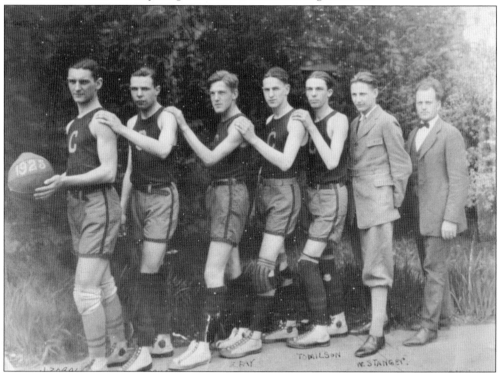

Boys' Basketball, 1925. The players on the Cranford High School basketball team in 1925 were, from left to right, Joseph Zobal, Norris Brisco, Richard Hanna, Everett Fay, Philip Tomlinson, and Wesley Stanger, with coach Alfred Holmes. The team photograph was not in the 1925 high school yearbook, perhaps because, as the boys' athletics summary stated, "It is sufficient to say that the season was not a success."

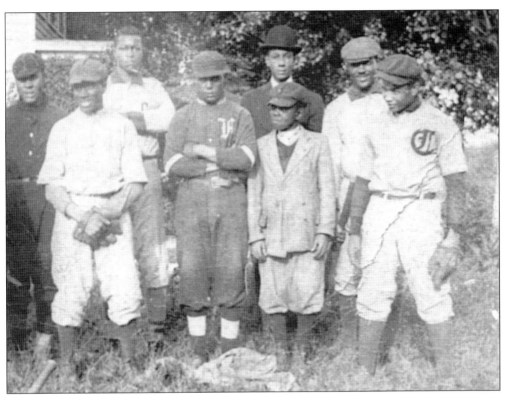

DIXIE GIANTS, C. 1925. The Dixie Giants were among the many all-Black baseball teams that played exhibition games in the early 1900s. The team was founded and managed by Ernest Tyree, Thomas Sperry's chef. They played locally at the ballfields at Union Avenue, Elizabeth Avenue, or near the Aldene railroad connection, frequently playing local all-white athletic clubs and beating them. The team dissolved around 1930.

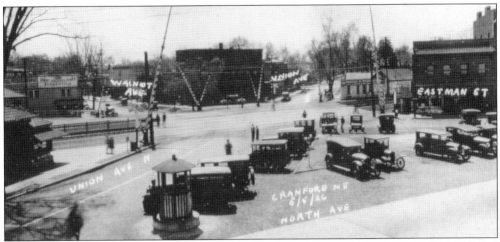

RAILROAD CROSSINGS, 1926. As rail traffic through Cranford increased, more people were killed or injured as they attempted to cross the street-level tracks. Despite the six sets of pedestrian and vehicle gates installed by 1926, accidents continued. In 1927, the New Jersey Board of Public Utility Commissioners ordered that the tracks be raised. The elevated tracks and a new station were completed in 1930.

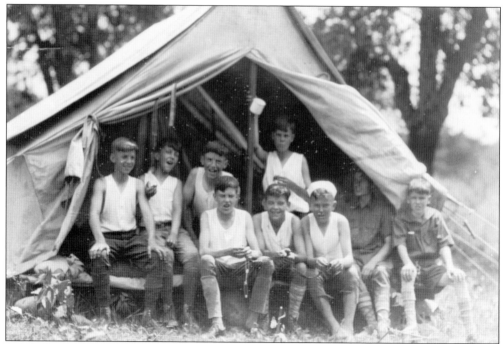

Boys' Camp, 1926. A Cranford boys' camp was established in 1925 when land was purchased at Silver Lake in Hope, New Jersey, with funds raised from Cranford citizens and organizations. From left to right, Robert Laurence, Dexter Bates, Bernard Gartlan, Lloyd Lisk, Allan Wittnebert, Robert Billingsley, Allan Woodward, Huyler Lisk, and Raymond O'Brian were probably among the boys clearing the site and building a proper camp in those early years.

Alden Street, 1927. Elevation of the railroad tracks from street level had not started, so looking down Alden Street from North Union Avenue in 1927, it was possible to see buildings on South Avenue, including the trolley power station. The Ehmling Building, on the left at the corner of North Avenue, was built in 1924, and in 1931 it briefly housed an 18-hole indoor golf course. Township offices took over the building in 1935.

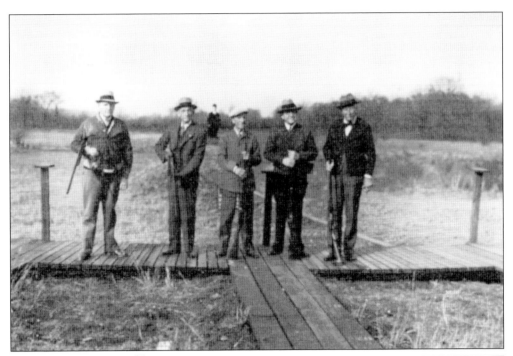

TRAP SHOOTING, 1927. Union County Park, later Lenape Park, offered trap and skeet shooting year-round along the Nomahegan Brook near the Kenilworth border. Trap shooting started in 1927 but was discontinued in 2005 to preserve the sensitive ecosystem in the area.

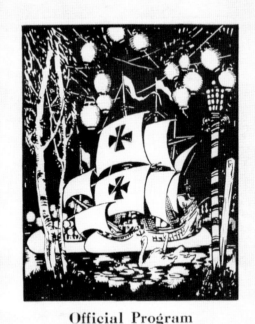

Official Program
Cranford River Pageant
July 7, 1928 Price 25 Cents

RIVER CARNIVAL PROGRAM, 1928. As the Rahway River carnivals continued to grow in popularity, attendees were becoming more unruly. There were increasing complaints from homeowners along the river, and notices were published in carnival programs asking spectators not to destroy shrubs or walk off with decorations, but the public did not change its behavior. The 1928 carnival would be the last for several decades.

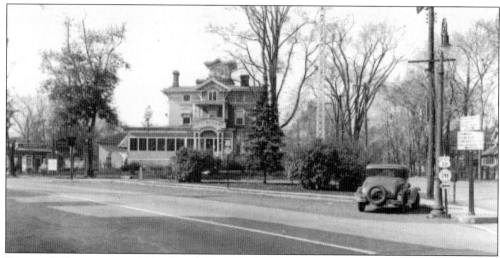

HAYASHI'S RESTAURANT, 1930. Frank M. Hayashi had worked for Thomas Sperry, but in 1916, he opened a restaurant in the Cranford Trust Building on North Avenue. In 1920, Hayashi's Restaurant moved to Miln Street, the former home of Dr. MacConnell, building an addition in 1924. In 1934, Hayashi's Restaurant was demolished to build the post office, and Frank Hayashi and his family moved to Japan.

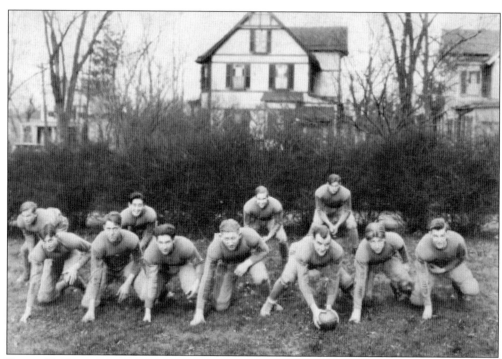

FRANK K. HAYASHI, 1928. Frank Hayashi (second row, second from left), whose parents owned Hayashi's Restaurant, was born in 1912 and died in 1984. He played football at Cranford High School, and in 1934 he and his parents moved to Japan. He was not drafted into the Japanese military in World War II, presumably because of his American roots. During the American occupation, he worked in the US Army Special Service Section.

ROOSEVELT SCHOOL KINDERGARTEN, 1929. Generations of Cranford kindergarteners listened to stories in front of this fireplace featuring a barnyard scene with a duck and hens. The Flint Faience Company fireplace had been installed in the Roosevelt School on Orange Avenue when it was built in 1927. In 2010, the township demolished the building, but the fireplace was saved, and it is now in the Cranford Community Center.

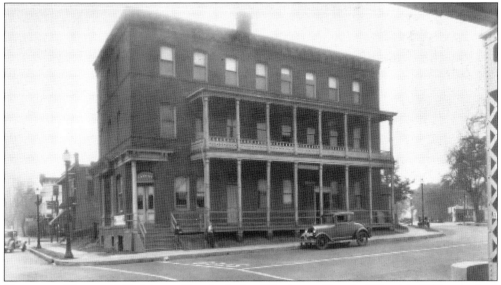

CRANFORD HOTEL, 1930. Martin Hess built the 17-bedroom Cranford Hotel in 1892 to replace an earlier hotel that had been on the site since 1885. The hotel was competition for the Central Hotel, which was in business a block away on Walnut Avenue from 1875 to 1929. This photograph was taken nine months after the railroad tracks that had run directly in front of the hotel were raised in January 1930.

STREET NAME SIGNS, 1930. In 1906, horizontal street signs were installed throughout town, but in 1929, officials decided to replace them with obelisk-shaped posts. Those with the blue letters on yellow ceramic tiles, like the one pictured, are the originals, manufactured by the Mueller Mosaic Company in Trenton, and one of the Cranford signs was even featured in a company catalog. Those with yellow letters on blue metal backgrounds are newer replacements.

RAILROAD STATION, C. 1932. The first train stop was built in Crane's Mills in 1844. It was replaced in 1864, and in 1906 yet another new station was constructed. Work began in 1927 on elevating the tracks from street level and building a new station, seen in this photograph. That station, in the style of Frank Lloyd Wright, was completed in 1930 and is still in use.

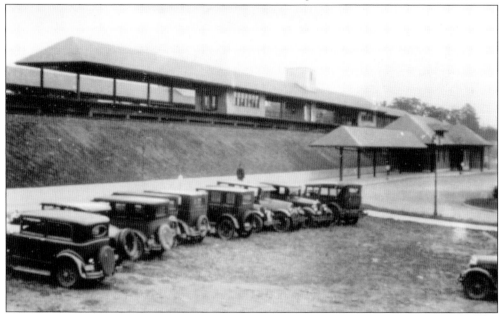

BOYS' BASEBALL, 1934. Captain and third baseman of the 1934 Cranford High School baseball team Charlie Griffiths (second row, fourth from left) was an all-around athlete. He led his team to seven wins out of 11 games, with a batting average of .357 that year.

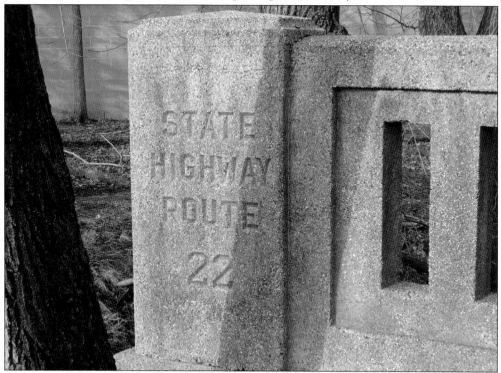

ROUTE 22, 1931. What is now Route 22 was called Route 29 in 1931. That year, New Jersey began to build a new highway, designated Route 22, from Rahway through Cranford to Paterson. A short stretch, Lincoln Avenue from North Avenue to South Avenue, was built, but then plans changed, and the rest of the roadway was never constructed. All that remains is this concrete bridge.

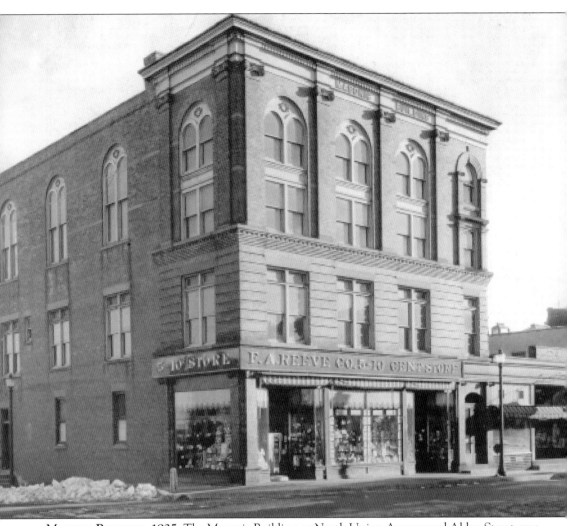

Masonic Building, 1935. The Masonic Building, at North Union Avenue and Alden Street, was built in 1902. Four stores were on the first floor, and township offices, lodge rooms, apartments, and banquet rooms were on the other three floors. L. Lehman & Company Grocers opened on the first floor in February 1903 with Walter Scholes as manager. Cranford's first bank, the Cranford National Bank, also occupied part of the building at one time. The building housed a succession of businesses over the years, including a feed store, a meat market, and a dry goods store. In 1935, Forrest Reeve opened F.A. Reeve 5 & 10 Cent Store, moving from 15 North Union Avenue. The building continued to change tenants and went through a series of alterations that gradually changed its original appearance. In 2020, a significant restoration of the whole building was undertaken, and the top three floors were converted to apartments.

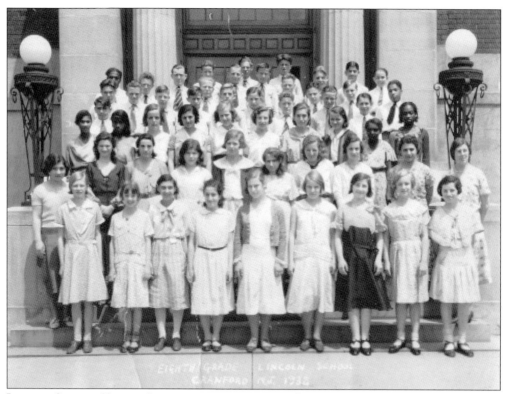

LINCOLN SCHOOL, EIGHTH GRADE, 1938. Growing enrollments required two new schools, so the Lincoln and Cleveland Schools were built in 1913. The Lincoln School, a primary school, was built at Centennial Avenue and Lincoln Avenue for about $38,000. A wing was added to the building in 1928. The Lincoln School remains Cranford's oldest continuously occupied school.

CHIMNEY CORNER, 1942. Chimney Corner was opened by James Eastmond in 1936 next to the train station. Virtually every organization in town, including the Lions, Kiwanis, and the Cranford Women's Club, held their meetings there. In 1950, the restaurant was sold and became the Coach and Four, then later Cervantes of Spain, then Bar Americana.

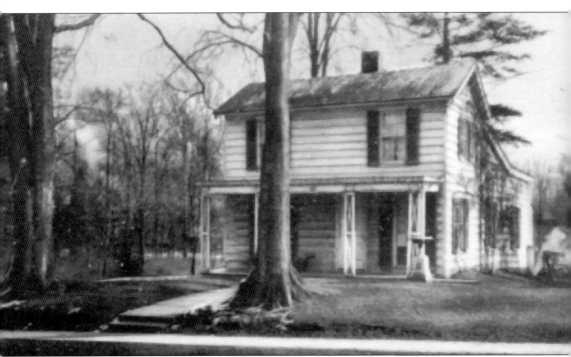

CRANE-PHILLIPS HOUSE, 1938. The Crane-Phillips House, on North Union Avenue, is on the National and State Registers of Historic Places, was part of the Historic American Buildings Survey of 1936, and was named to the Save America's Treasures program. The project to restore the house as a rare example of a small plan book cottage in the architectural style of Andrew Jackson Downing began in 1996, and the original exterior colors were restored in 1998. Henry and Cecilia Phillips, some of the town's earlier residents, purchased two and a half acres from Josiah Crane Jr. in 1867, and they had local builder William C. Wells expand the one-room building that was there. Henry Phillips was an engraving artist and an inventor, patenting an early forerunner to today's kitchen range hood. He and his older brother, Dr. Charles H. Phillips, the inventor of Phillips' Milk of Magnesia, along with Josiah Crane Jr. played important roles in the building of the Grant School on Holly Street, the first school on the north side of town.

ALAN OKELL, 1942. Alan Okell lived on Willow Street, graduated from Cranford High School in 1936, and attended Rutgers University. He joined the Army Air Corps in 1941, received his commission in 1942, and became an aviation instructor. He died in a training flight crash in 1943, three weeks after his promotion to first lieutenant. A street off Lexington Avenue is named in his honor. (Courtesy of Cranford 86.)

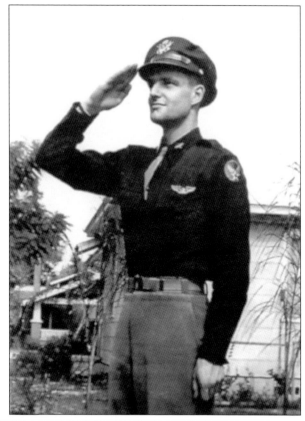

WELCOME HOME PARADE, 1946. On October 12, 1946, over 15,000 people turned out for a parade to honor veterans returning from World War II. Seen here are members of the Veterans of Foreign Wars marching down North Avenue. The parade was the highlight of daylong activities. Veterans of all wars marched, accompanied by floats and bands.

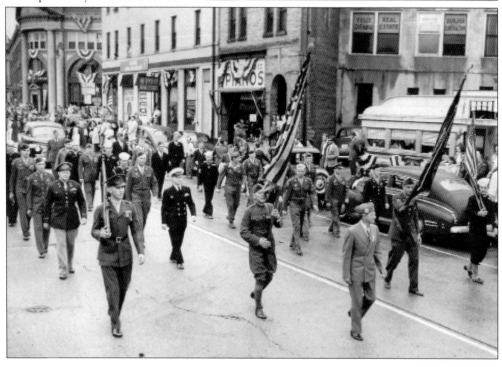

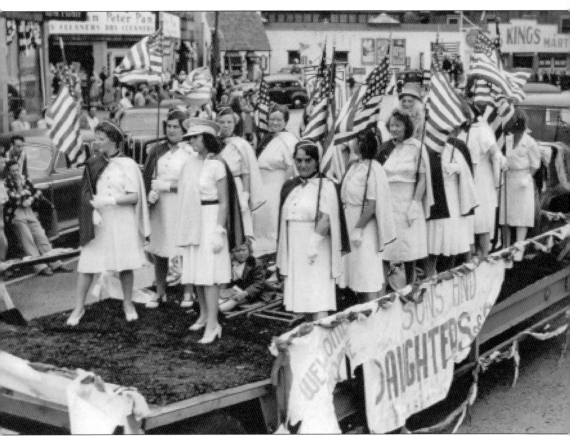

CRANFORD'S 75TH ANNIVERSARY, 1946. The planned weeklong observance of Cranford's 75th anniversary in 1946 was scaled back because the impact of World War II was still being felt by Cranford's residents. The celebration committee felt it was not appropriate to hold festivities while so many people had lost loved ones and were suffering from war fatigue. However, there were other celebrations that year, including welcome-home parades like this one, held on October 12 with a float by the Veterans of Foreign Wars Auxiliary. And there was a 75th anniversary salute at the Fourth of July fireworks in Nomahegan Park. Before the fireworks, Cranford mayor George Osterheldt remarked on the town's progress over the past 75 years and its healthy condition, noting that the population in 1880 was 1,184 and in 1946 was estimated to be more than 16,000. After a musical performance, the fireworks display featured pieces welcoming men and women home from the service and honoring Cranford's 75th anniversary.

Four

CELEBRATING CRANFORD'S PROGRESS 1947–1971

Cranford celebrated its first 100 years in grand style in 1971. Events took place throughout the year, with the climax the first week in June. On June 6, a river carnival in Nomahegan Park was attended by 10,000 people. A parade through town took place on June 12. A special edition of the *Cranford Citizen and Chronicle* was published to tell Cranford's story.

Cranford's population in 1970 was over 27,000, and it has not reached that number since.

Construction of single-family homes continued, but apartment complexes like the Parkway Village and the Riverside Apartments were arriving. Houses were being built farther from the center of town, including the development of the College Estates on the north end of town in the 1950s. Schools were built or expanded to accommodate the baby boom, with four elementary schools and two junior high schools opened. Union Junior College built a new campus on the former Nomahegan Golf Course. In the early 1960s, the library was built on Walnut Avenue.

The construction of the Garden State Parkway, or Route 4 as it was called, began in 1946. Several streets were eliminated, and the course of the Rahway River was adjusted. The town dump, which was now visible from the Parkway, was transformed into an industrial and office park. Two modern buildings designed by noted architects, the IBM Building and the City Federal Savings Round Bank, were built, but both were later demolished in the 1990s.

It was a period of social change. Life in Cranford in 1947 was different from life in 1971. Starting in the early 1960s, concerned citizens and local clergy were active in the civil rights movement. Opinion was divided about the Vietnam War, and 12 soldiers from Cranford lost their lives in the conflict. Women were beginning to question their traditional roles.

And yet, Cranford Days, daylong programs that were started in the late 1940s, continued to celebrate all aspects of Cranford life well into the 1970s.

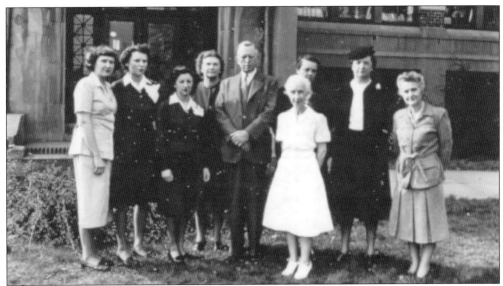

VISITING NURSE ASSOCIATION, 1948. The Cranford chapter of the Visiting Nurse Association was formed in 1923 at the urging of the Village Improvement Association. The nurses provided in-home bedside care to members who paid a subscription of $1 per year. Shown here, from left to right, are Dorothy Sauer, Dorothy Koeppler, Josephine Rudnicki, Kathryn Popp, Miss Kolloy, Elizabeth Durrell, B. Cop, and Alice Doran, with Mayor George Osterheldt.

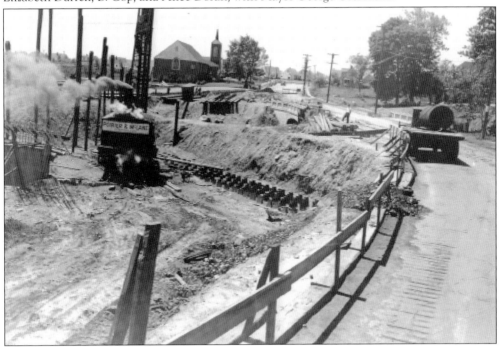

GARDEN STATE PARKWAY, 1949. Construction of Route 4 or the Garden State Parkway through Cranford officially started on November 9, 1946, when ground was broken at a ceremony attended by the governor and other dignitaries. Construction required some engineering around the Rahway River at Raritan Road, rerouting some of the waterflow. Osceola Presbyterian Church can be seen in the background in this photograph.

TELEPHONE SERVICE, 1950. The first private telephone was installed in Cranford in 1899. Callers had to crank the telephone to get an operator to place a call, but in 1913, a new battery system let callers alert the still-required operator without cranking. In February 1950, a new system allowed people to directly dial local calls, with direct dialing to the rest of the United States coming in 1956.

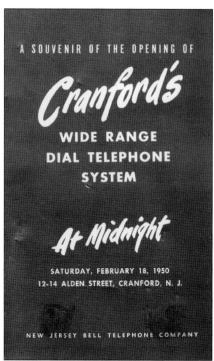

A SOUVENIR OF THE OPENING OF

Cranford's

WIDE RANGE
DIAL TELEPHONE
SYSTEM

At Midnight

SATURDAY, FEBRUARY 18, 1950
12-14 ALDEN STREET, CRANFORD, N. J.

NEW JERSEY BELL TELEPHONE COMPANY

TRUBENBACH FEED AND SEED, C. 1950. Charles Ernest Trubenbach took over a feed and grain store from C. Pounty in 1922 and moved it from North Union Avenue to South Avenue. He sold seeds, grains, poultry, and fertilizer, moving into garden supplies in the 1960s. In 1945, he opposed a petition for a town ordinance to stop the raising of livestock in Cranford.

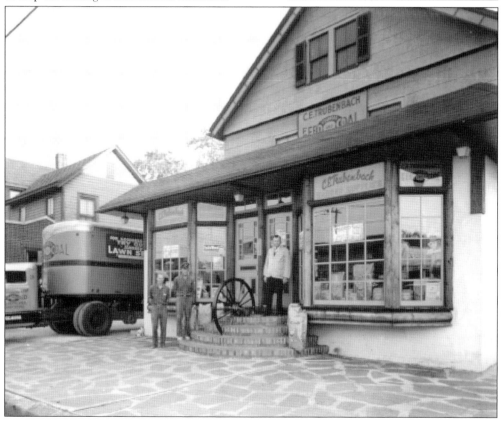

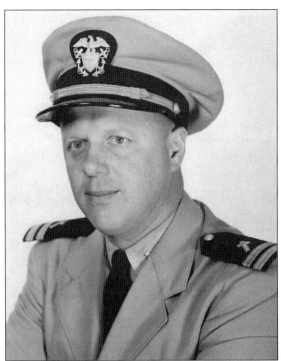

REV. ARNOLD J. DAHLQUIST, 1952. Rev. Arnold Dahlquist served Calvary Lutheran Church on Eastman Street for 29 years, retiring in 1980. This photograph is from the time he served as a naval chaplain, starting in World War II and ending in 1970. Reverend Dahlquist preached about civil rights in the 1950s and 1960s and was active in causes to prevent homelessness and hunger. He died in 2003 at the age of 87.

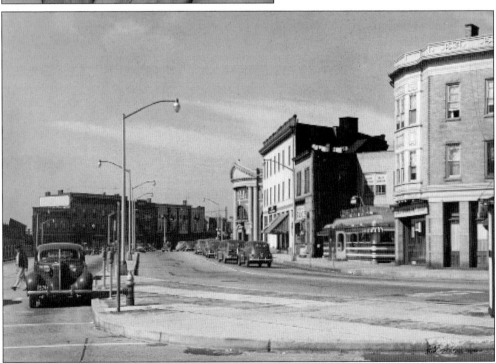

NORTH AVENUE, C. 1952. Pictured on the right among the businesses that are part of Cranford's downtown is a diner at 7 North Avenue, between Alden Street and North Union Avenue. The Billias family opened their first diner at that address in 1923 and replaced the building in 1928, 1942, and 1953. The family sold the business in 1966, but a diner still operates at the site.

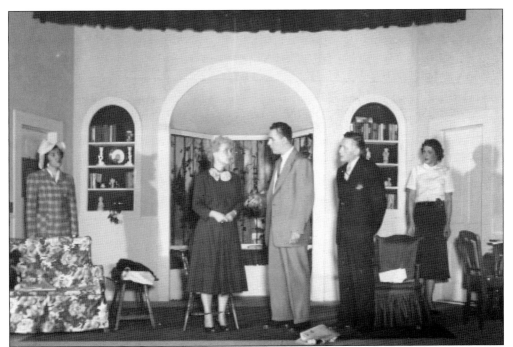

CRANFORD DRAMATIC CLUB, 1953. The cast of the comedy *The Curious Savage* is pictured onstage during a Cranford Dramatic Club performance in 1953. The club, organized in 1919, grew to a community theater offering plays and musicals. Early performances were given in church and school auditoriums and at the Cranford Casino. The club's theater, on Winans Avenue, was built in 1957 and has since undergone several renovations.

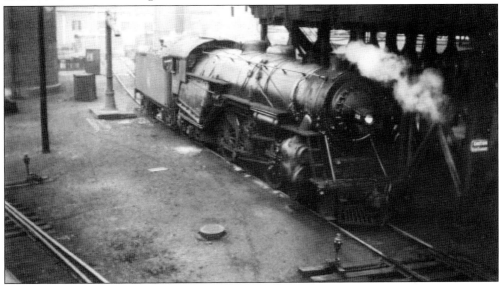

CRANFORD ROUNDHOUSE, 1953. The roundhouse was constructed between 1913 and 1915 by the Jersey Central Railroad. The original brick roundhouse, with eight locomotive stalls and a turntable that allowed locomotives to change direction, was last used by the railroad in 1954. It now houses the Cranford Department of Public Works. It was named as one of Preservation New Jersey's 10 Most Endangered Historic Places for 2020.

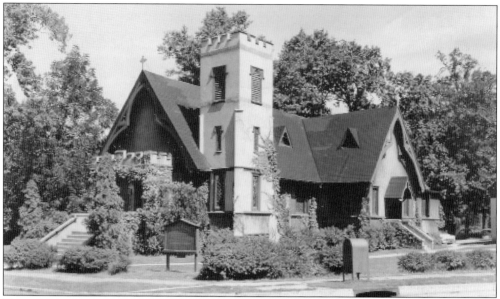

TRINITY EPISCOPAL CHURCH, 1955. Trinity Episcopal Church was founded in 1872, and the first services were held in the little red schoolhouse on South Union Avenue. The Carpenter Gothic–style building that now houses the church on North and Forest Avenues was built in 1875. It was redesigned to include a castle-like tower in 1922 but was restored to its original Victorian look in 2010.

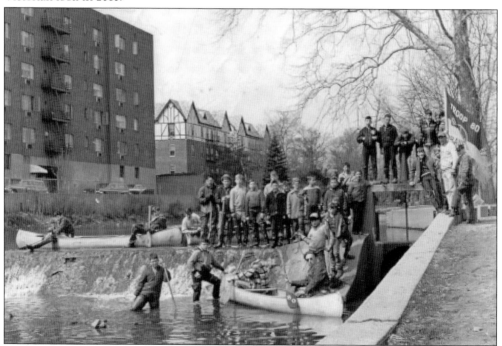

BOY SCOUTS RIVER CLEANUP, C. 1956. Boy Scouts of Troop 80 from the First Presbyterian Church work on their annual river cleanup near North Union and Springfield Avenues. The first Boy Scout troops in Cranford were established around 1910. Through the years, Scouts have performed public service projects throughout town.

FIRST AID SQUAD, 1957. The Cranford First Aid Squad was only a few years old when it marched in the Memorial Day parade on May 30, 1957. Formed in November 1953, the all-volunteer squad still provides ambulance assistance to the fire and police departments. The squad is headquartered at Centennial and North Avenues.

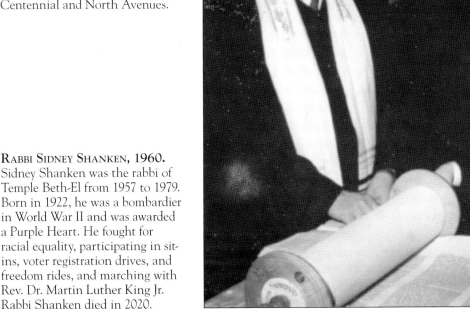

RABBI SIDNEY SHANKEN, 1960. Sidney Shanken was the rabbi of Temple Beth-El from 1957 to 1979. Born in 1922, he was a bombardier in World War II and was awarded a Purple Heart. He fought for racial equality, participating in sit-ins, voter registration drives, and freedom rides, and marching with Rev. Dr. Martin Luther King Jr. Rabbi Shanken died in 2020.

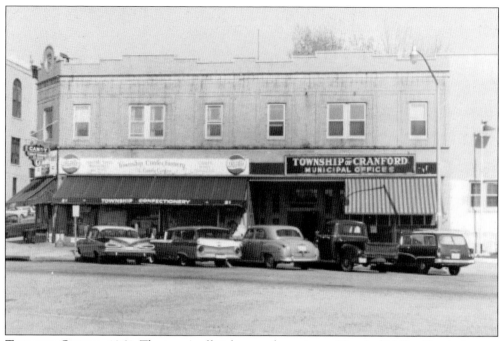

TOWNSHIP OFFICES, 1961. The town's officials started meeting at Cranford Hall at North Avenue and Eastman Street in 1876. They then moved to the Masonic Building and the Darsh Building before relocating to the Ehmling Building, pictured here, at North Avenue and Alden Street in 1935. The Municipal Building on Springfield Avenue, where the township committee now meets, was built in 1962.

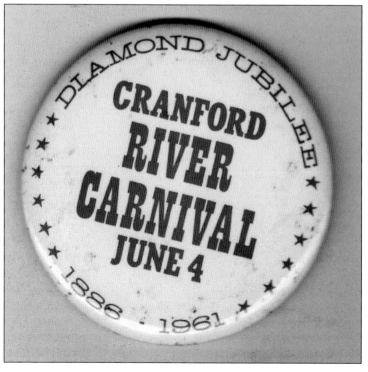

RIVER CARNIVAL RETURNS, 1961. After an absence of several decades, the Rahway River carnival returned in 1961 to celebrate its 75th and Cranford's 90th anniversary. The event was no longer an evening affair on the Rahway River but was now held during the day and, because of environmental concerns, took place on Nomahegan Lake. Prizes were awarded for floats sponsored by Cranford civic groups.

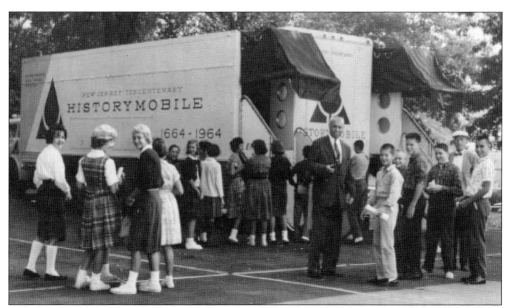

TERCENTENARY HISTORYMOBILE, 1961. The New Jersey State Tercentenary Committee's Historymobile toured the state from 1961 to 1964 and came to Cranford on October 13, 1961. The trailer, with exhibits on early New Jersey history, parked on the grounds of the Cleveland School on its first stop in Union County and was visited by over 1,700 adults and students.

FIRST CHURCH OF CHRIST, SCIENTIST, 1962. The Christian Science building at the corner of Springfield Avenue and Miln Street looked much the same in this 1962 photograph as when it opened in 1909 and as it does today after being converted to condominiums in 1988. Local members organized their church in 1898 and raised $25,000 to construct the building, which included a 300-seat auditorium, a Sunday school room, and a reading room.

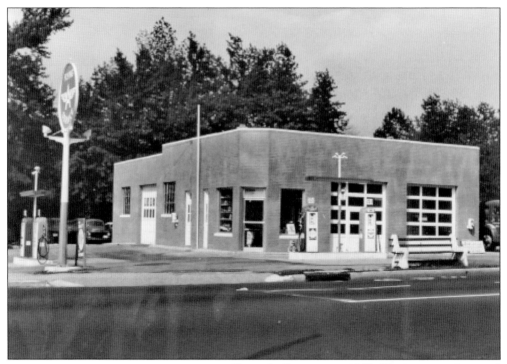

GRECO'S GARAGE, c. 1962. Having moved several times, Greco's ended up on the corner of South and Centennial Avenues in 1939. It sold Shell, Flying A, then Getty gasoline and ran a repair shop. Casper Greco started the business in 1932, and it was later taken over by his son, Robert Greco. The station was demolished, and Commerce Bank opened on the site in 2001, replaced by TD Bank in 2008.

CRANFORD SEAL, 1963. Cranford's official seal, designed by Leslie Crump, was adopted by the township in 1963. The seal has been modernized but still features a crane symbolizing the Crane family, 13 stars and a plow from the state seal, the mills that once stood on the Rahway River, the date of Cranford's incorporation in 1871, and Cranford's motto, "Friendship and Progress."

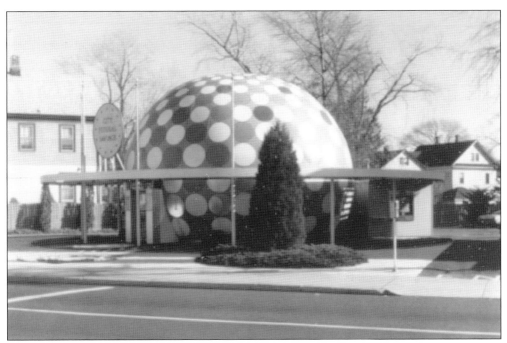

BUBBLE BANK, 1964. Located at South and Walnut Avenues, the Bubble Bank was the temporary location of the City Federal Savings Bank while the Round Bank was being built. The "Glo Dome," as it was called, opened in October 1964 and was made of plastic that was held up by air pressure. It was replaced by several different restaurants and finally the Calderone Building, which stands on the site today.

REV. CHARLES WATTERS, 1965. Fr. Charles Watters, born in 1927, served at St. Michael's Church from 1964 to 1965. As a chaplain major, he volunteered for two tours of duty in Vietnam. He was killed in action in 1967 and was awarded the Congressional Medal of Honor for dragging several soldiers to safety. The flagpole in front of St. Michael's is dedicated to him. (Courtesy of Seton Hall University Archives.)

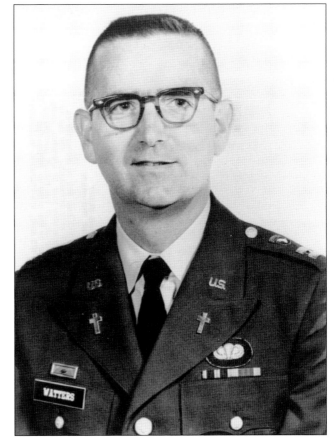

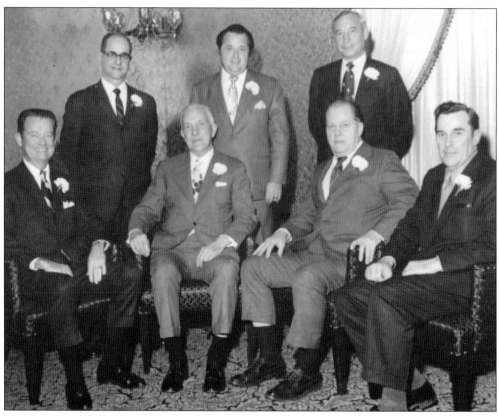

CRANFORD'S MAYORS, 1967. Cranford's mayors past and present posed for a photograph in 1967. From left to right are (first row) John Brennan (1957–1958), C. Van Chamberlin (1961), Fred Andersen (1953–1956), and Wesley Philo (1966); (second row) Ira Dorian (1959–1960), H. Raymond Kirwan (1964–1965), and Ed Gill (1967–1969).

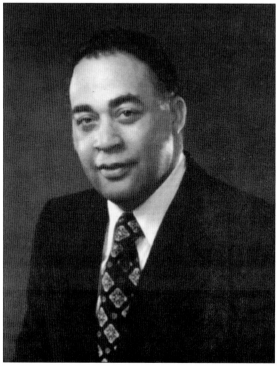

JAMES AVERY, 1968. James Avery was born in 1923 and grew up on Johnson Avenue. An outstanding Cranford High School athlete and scholar, he earned bachelor's and master's degrees at Columbia University then taught at Cranford High. He went on to a 30-year executive career with Exxon and served as president of two national organizations. He was a strong advocate for education, especially among minority youth.

RAYMOND ASHNAULT, 1969. Raymond Ashnault grew up on Garden Place loving cars and motorcycles. He graduated from Cranford High School, enlisted in the Army in 1968, and went to Vietnam. He fought in several heated battles and was awarded a Purple Heart, two Bronze Stars, one of which was for valor, and other citations. He was killed near Quan Loi in August 1969. (Courtesy of John Ashnault.)

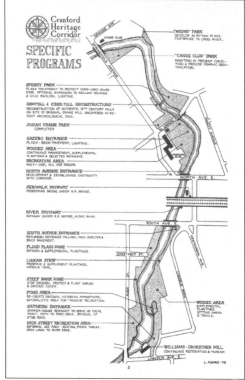

CRANFORD HERITAGE CORRIDOR, 1971. The Cranford Heritage Corridor was proposed in 1971 as a series of 20 special projects, including a sawmill reconstruction. The corridor was to provide a riverwalk along the Rahway River Parkway from Orange Avenue to Droescher's Mill. In 2019, the Riverwalk Restoration Project began repairing and rebuilding the southern area, including the skating pond that had been part of Severin Droescher's 1912 Lincoln Park development.

69

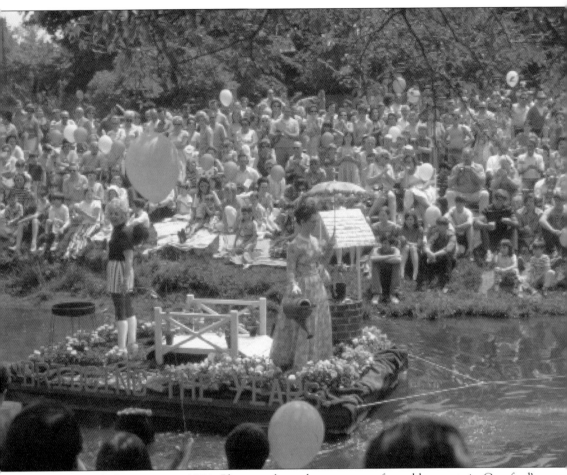

CRANFORD'S CENTENNIAL, 1971. Photographs and a summary of notable events in Cranford's first 100 years were part of a commemorative booklet published in 1971. During the weeklong centennial celebration, over 10,000 people, many in Victorian dress, watched the river carnival on Nomahegan Lake. Progress through the Century was the theme of the event on Sunday, June 6, which included a parade of 18 floats, one of which is seen here, sponsored by local organizations and reviewed by officials from Cranford and nearby communities. Other activities in the park that day included an antique car exhibit and a band performance. Seven former mayors judged a family costume contest. The week culminated with a centennial parade of 1,500 marchers through downtown on June 12, again with floats and music. Other events that week included a group greeting morning commuters with doughnuts, a fair, and the dedication of Josiah Crane Park. A special edition of the *Citizen and Chronicle* was published with articles celebrating Cranford's major milestone.

Five

CELEBRATING CRANFORD'S SPIRIT 1972–1996

As in anniversaries past, Cranford's 125th in 1996 included a river carnival and a parade. But new to this celebration was a circus, a Fourth of July festival, and a ball in Hanson Park. A gazebo was installed across from the Municipal Building to commemorate the anniversary.

The United States celebrated its Bicentennial in 1976, and Cranford celebrated that with events including burying a time capsule. To commemorate the Bicentennial of the Constitution in 1987, the Peace Site was dedicated in front of the post office.

Cranford experienced a series of floods in the early 1970s, and in 1980 the Lenape Park flood control basin and the Brookside Place basin were completed to help stem the high waters. The problems persisted.

Cranford's population declined from 27,391 in 1970 to 24,573 in 1980. The decline meant that some schools were no longer needed. Cleveland School was closed in 1974 and converted to offices. Roosevelt School was closed in 1979, but the building then housed a private school. Bloomingdale School closed 1981, although it did reopen later. The Board of Education kept its offices at the Lincoln School, but only a few of the classrooms were used for students.

A new firehouse was built on Springfield Avenue to replace the one that had been in use for decades on North Avenue. Cranford had just about run out of buildable land, so remodeling and home expansions replaced new construction. Cranford was starting to lose some of its significant buildings, but a video tour done in 1988 by David Holden archived some of the town's historic architecture.

The town saw its first woman to serve on the township committee and as mayor and the first woman member of the police department.

As Cranford ended its first 125 years, the *Cranford Chronicle* published a special section with the subtitle "A Community 125 Years Strong."

BROOKSIDE PLACE SCHOOL, FIRST GRADE, 1974. Students in Room 4 of the first grade of the Brookside Place School pose for their formal school photograph. The school opened in November 1954 with 12 school rooms. Along with the Walnut Avenue School, it was one of the two elementary schools to open that year.

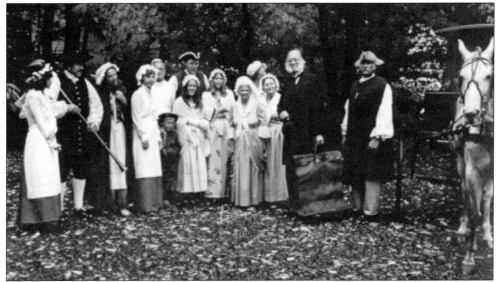

MAIL STOP AT DROESCHER'S MILL, 1974. A coach reenacting the mail route between Plainfield and Elizabeth arrived at Droescher's Mill on October 16, 1974, met by a group of people in colonial garb. Attendees heard Homer Hall, at center with the whiskers and dressed as Josiah Crane, talk about when Lincoln Avenue was part of the Old York Road, built in the 18th century to connect New York and Philadelphia.

CARL HANSON, 1979. Dr. Carl Hanson is pictured in the garden at the back of his house on Springfield Avenue. Starting his pediatric practice in Cranford in 1934, he saw virtually every child in Cranford at his home office over the years. The house, built in the mid-1800s, was almost demolished in the 1980s but was saved and is currently the headquarters of the Cranford Historical Society.

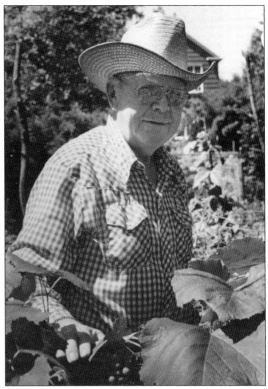

CRANFORD CANOE CLUB, 1980. The Cranford Canoe Club on Springfield Avenue was built in 1908 as the clubhouse for the Ulhigh Canoe Club. The Ulhighs sponsored several regattas before fading away around 1915, and their building became a canoe livery. In 1934, members of the Cranford Canoe Club moved from across the street into this building, which was renamed the Cranford Canoe Club. It continues to rent canoes.

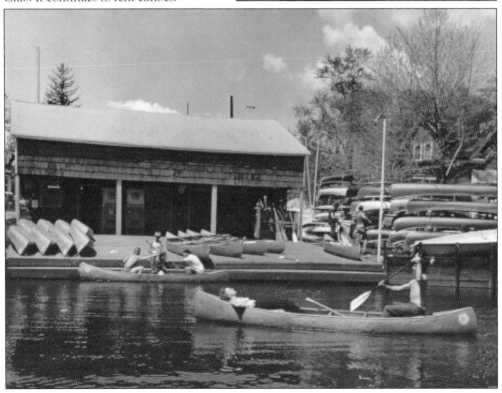

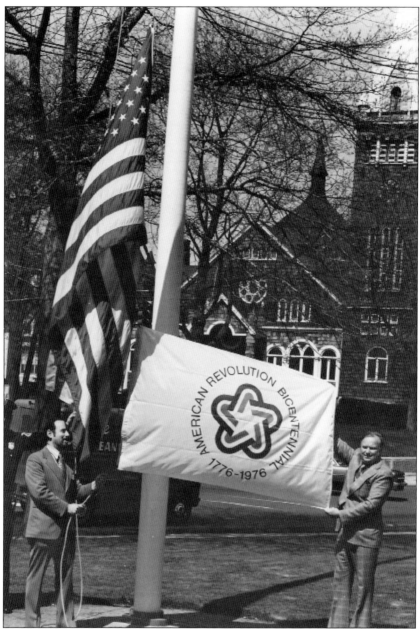

US Bicentennial, 1976. Events were held in Cranford throughout 1975 and 1976 to commemorate the Bicentennial of the United States. A Bicentennial dinner was sponsored by the Village Improvement Association in April 1975 to kick off the celebration, and later that month, Mayor Burton Goodman (left) and Bicentennial chair Henry Koehler (right) raised a special Bicentennial flag at the Municipal Building. In June, Lincoln Avenue temporarily became Old York Road, the original name of the route that ran from New York to Philadelphia. In May 1976, a Bicentennial Ball was sponsored by the Cranford College Club, and then there were fireworks on July 4. The biggest event surrounding the Bicentennial was a river carnival sponsored by the Jaycees in June. Fifteen floats that had been created by individuals and groups, many with patriotic themes, were viewed by over 15,000 people as they were towed in Nomahegan Lake.

River Carnival Bicentennial Float, 1976. River carnivals had come back to Cranford in 1961, but they were now held on Nomahegan Lake and were usually organized in conjunction with other events. In 1976, a carnival took place as part of Cranford's Bicentennial celebration, and Henry Koehler shared a patriotic float with an almost life-size artificial horse.

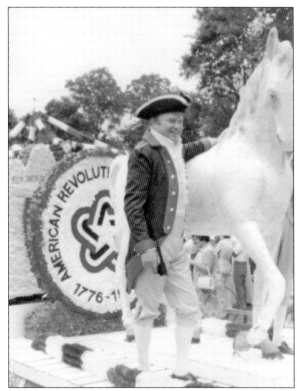

Bicentennial Capsule, 1977. Mayor Barbara Brande, center, and a group of Cranford citizens attended a ceremony to bury a Bicentennial capsule containing newspapers, photographs, and memorabilia. The 12-by-13-by-30-inch copper box encased in a concrete vault was buried in front of the Municipal Building on March 20, 1977. A plaque on the vault calls for it to be opened in 2076.

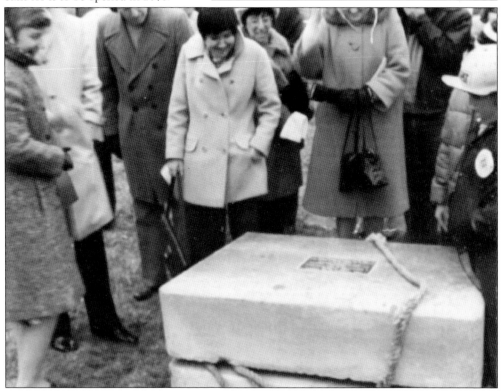

NORRIS-OAKEY HOUSE, 1976. Seen here in a state of disrepair, one of the oldest houses in Cranford had been scheduled for demolition around 1975. The Norris-Oakey House, on Orange Avenue, was built about 1750 by Nathaniel Norris and later owned by Civil War veteran William Oakey. Originally a small farmhouse, it was transformed several times over the years. The left side of the house is part of the original farmhouse, and a full story and a half were added to that older side at some point. The large 1820 addition on the right featured taller windows. The township acquired the house in 1975 and leased it to the Cranford Heritage Corridor, a nonprofit that failed to raise the required funds to rehabilitate it. It was returned to the town in 1981 and was purchased by individuals who have since restored it.

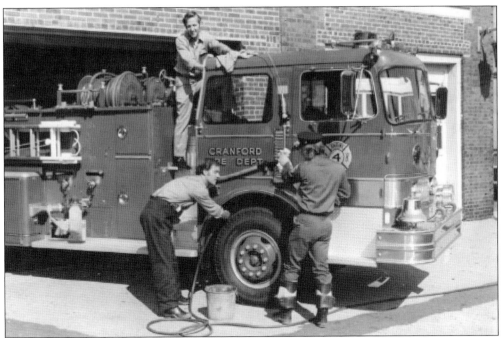

FIRE ENGINE MAINTENANCE, C. 1980. Firefighters Harvey Merwede (top), Steve Patterson (bottom left), and George Reagan (bottom right) polish a fire engine in front of the new firehouse on Springfield Avenue near North Avenue. The first firehouse in Cranford was built in 1909 on North Avenue and was finally replaced by the new building in 1980.

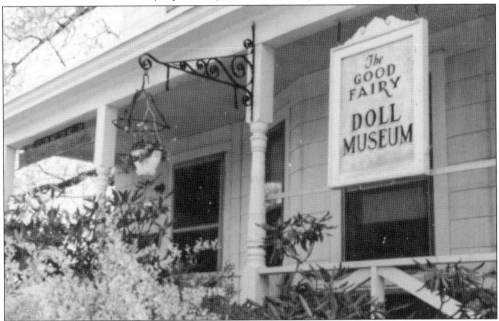

GOOD FAIRY DOLL MUSEUM, 1980. In 1971, Elizabeth Beck Connors opened the Good Fairy Doll Museum on Walnut Avenue. She and her husband, James, had thousands of dolls, which she exhibited in the museum as well as around the state at churches, charities, and libraries. They also repaired and sold dolls. The museum closed in 2003 after the deaths of the owners.

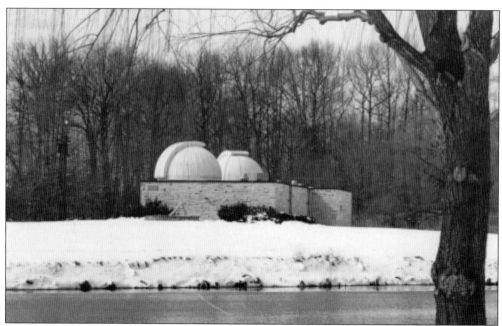

SPERRY OBSERVATORY, 1981. The William Miller Sperry Observatory stands on the Union County College campus. It was built in 1967 through a $100,000 endowment to honor William Sperry, who was president of Sperry & Hutchinson Company, creator of S&H Green Stamps. Operated by the Amateur Astronomers, Inc., it is one of seven operating public observatories in New Jersey, with two large telescopes for amateur use.

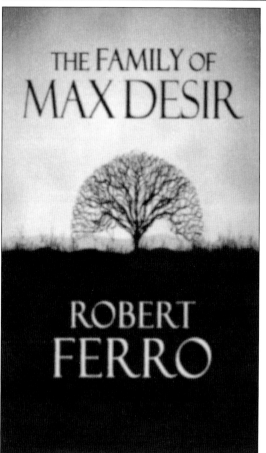

THE FAMILY OF MAX DESIR, 1983. Author Robert Ferro graduated from Cranford High School in 1959, then from Rutgers University, and earned a master's degree from the University of Iowa. His book *The Family of Max Desir* was set in a fictionalized version of Cranford, including an Indian River representing the Rahway River, and explored the issue of a family's acceptance of their son's homosexuality.

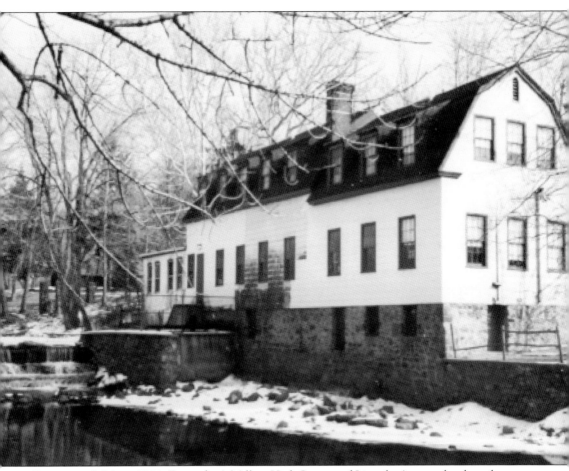

DROESCHER'S MILL, 1981. Droescher's Mill, at High Street and Lincoln Avenue, has been known as Rahway River Mill, Williams' Mill, Vreeland's Mill, or the Old Mill, and it is the only mill still surviving of the 11 that once stood along the Rahway River in Cranford. Part of the mill's foundation could date from 1779, but the wooden structure has to date after 1821, when the original mill burned down. Over the years, the mill had been used for the manufacture of woolen goods, wooden objects, oil stones, and pipe organs, and it currently houses several commercial enterprises. Severin Droescher, an early developer of Cranford and a member of the township committee, manufactured razor hones in the building and sold them through his New York cutlery business, the Cranford Razor Company. The mill is on the National Register of Historic Places and was designated a Cranford historic landmark in 2014 for its significance in the commercial development of Cranford and its association with Severin Droescher.

HOMER HALL, 1985. Homer Hall, who was born in 1911 and died in 2008, lived in Cranford for 65 years. He was known for his muttonchop whiskers and for his impersonation of Josiah Crane at town events, as seen here. He wrote *300 Years at Crane's Ford*, a history of Cranford, in 1964.

RIVER CARNIVAL CENTENNIAL, 1986. The centennial celebration of the first river carnival included a parade of 15 floats sponsored by various Cranford groups, like this one from the Rotary Club. Festivities also included a re-enactment of the Santiago Porcella canoe cruise that inspired the first river carnival in 1886.

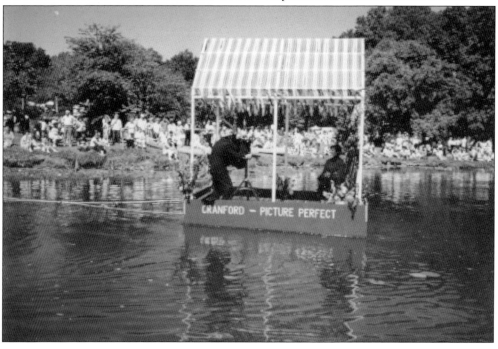

CRANFORD PEACE SITE, 1987. On September 19, 1987, Thomas Jefferson (actor Brian Hayes) joined Douglas Nordstrom and other local dignitaries to dedicate the area in front of the post office as the Cranford Peace Site and to plant a Living Legacy tree. The ceremony, along with a series of lectures and a regatta in September, were all part of Cranford's Constitution Bicentennial celebration.

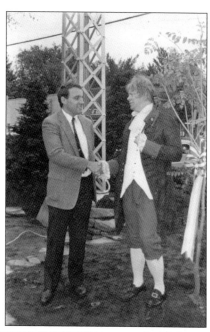

HUGH S. DELANO, 1991. Hugh S. Delano, a 1952 Cranford High School graduate, had his first byline in the *Cranford Chronicle* while still in high school. He was a celebrated sportswriter who was inducted into the National Hockey League Hall of Fame in 1991 after a career of writing columns and books about major New York sports teams. He died in 2015. (Courtesy of the Delano family.)

CRANFORD GIRL SCOUTS
1929-1994
65ᵗʰ ANNIVERSARY

GIRL SCOUTS, 1994. In 1929, the first Girl Scout troop in Cranford was chartered. Scouts met at the Little House, now the site of Girl Scout Park, from 1934 until 1964, when the building on Springfield Avenue was razed. Scouts have been contributing to the community since the first troop was formed.

LYNWOLD, 1995. Lynwold, sometimes spelled Linwold, was built in the 1860s by P.A. Ellis at the corner of North Union and Forest Avenues. The original house was enlarged and columns added to the front porch in the 1880s, and the carriage house in the back was built in the early 1900s. The many owners of the house included T.A. Sperry, but not all of them lived there but rather rented it out.

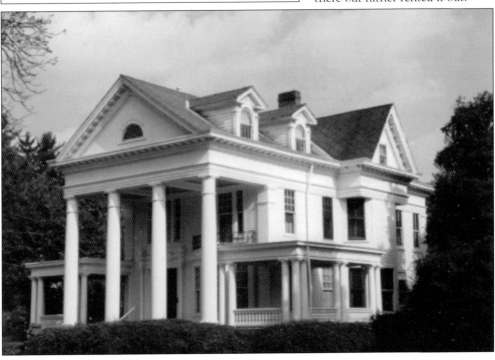

125TH ANNIVERSARY QUILT, 1996. Forty-two Cranford civic, religious, and athletic groups contributed squares to a quilt depicting Cranford's history, landmarks, organizations, and natural resources. The quilt, which was done over several months, was on display at the 125th anniversary festivities and now hangs in the Municipal Building.

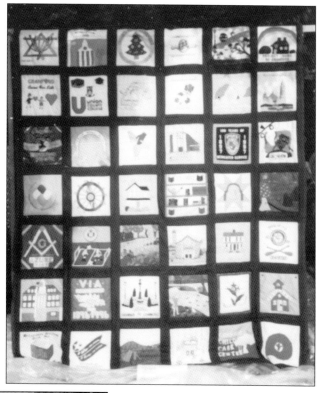

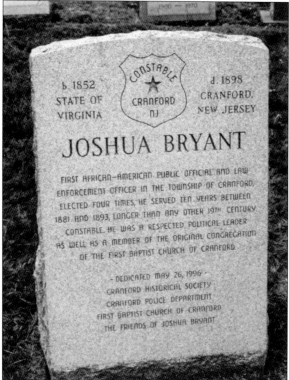

JOSHUA BRYANT HEADSTONE, 1996. Joshua Bryant, the first Black man to hold elected office in Cranford, was buried in an unmarked grave in Fairview Cemetery when he died at the age of 46 in 1898. Coming to Cranford about 1873, he was first elected constable in 1881 and was re-elected three times. Researchers located his grave in 1994, and a new headstone was dedicated in 1996. (Courtesy of the Cranford Police Department.)

CRANFORD'S 125TH ANNIVERSARY, 1996. As in all of Cranford's celebrations, one of the highlights of Cranford's 125th anniversary, held over the weekend of June 8 and 9, 1996, was a river carnival. The carnival in Nomahegan Park on Sunday featured 20 floats and decorated canoes sponsored by individuals, businesses, and civic groups. Prizes were given in five different float categories by judges who reviewed them from a grandstand. Games, concerts, a historic costume contest, and a pie-eating contest were part of the festivities. A stage was set up downtown on Saturday, and entertainment included music performed by a one-man band as well as a traditional band and a storyteller. Downtown streets featured arts and crafts, food, and a petting zoo. Forty-two civic, religious, and athletic groups sewed squares to create a quilt that was presented to the township and would be exhibited in the library. And later that month, the gazebo across from the Municipal Building was erected in honor of Cranford's first 125 years.

Six

CELEBRATING CRANFORD'S STRENGTH 1997–2021

In 2021, Cranford commemorates 150 years since its incorporation. Festivities are planned, and the town's citizens will celebrate as they have on every other significant anniversary since the town began in 1871.

In the years between 1997 and 2021, Cranford witnessed events that brought fear and sorrow to the town as well as the rest of the world. The attack on the World Trade Center on September 11, 2001, left many shaken and six of Cranford's citizens dead. The COVID-19 pandemic that began in March 2020 turned Cranford's usual social activities into a memory.

On a local level, Hurricane Irene in 2011 left a good portion of the town underwater and property destroyed. Old Peppy on Lincoln Avenue, the tree that had been the symbol of the town, was taken down in 2015. The trolley power station that stood on South Avenue was demolished in 2016. The Cranford Theater closed in 2019 after being in business since 1926 but was reopened at the last minute, only to be closed again because of the pandemic in 2020.

Through it all, Cranfordites found ways to celebrate with friends and family. Annual events like the Halloween Parade and Santa's arrival on the fire engine continued. New events like the Rubber Ducky Derby and Porchfest drew people to the town. Cranford's downtown was voted the best in New Jersey two years in a row, in 2018 and 2019.

Two large apartment developments, Cranford Crossing, built in 2004, and the Riverfront at Cranford Station in 2011, changed Cranford's downtown area.

Some of the town's memories were restored. The flagpole that had been erected in 1918 but taken down in 2003 was reinstalled in 2008. Murals depicting scenes from Cranford's history that had been painted in the 1930s for the high school were found, repaired, and installed in the Municipal Building. Other murals that have hung in the post office since it was built in 1936 were restored to their former glory.

The people of Cranford look forward to celebrating another 25 years and more.

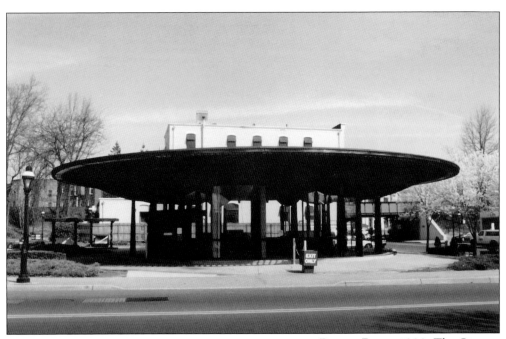

ROUND BANK, 1998. The City Federal Savings Bank, or the Round Bank, was designed by noted architect Edward Durell Stone. It was completed in 1968 at the corner of South and South Union Avenues on the site where Oscar Hess had opened a plumbing business in 1910. The bank was demolished in 1999 to make way for Cranford Crossing.

RIVER JUBILEE, 2007. The River Jubilee, held in Hanson Park in 2007, paid homage to the carnivals of old on the Rahway River. The program cover referenced a float that had been part of the 1920 carnival, and the event included guests dressed in Victorian attire. The River Jubilee was held to raise funds for the conservation and improvement of Hanson Park, an effort that began in 2004.

WORLD WAR I FLAGPOLE, 2008. The flagpole was originally dedicated in 1918 to celebrate the start of the third Liberty Bond drive during World War I. It was financed by the First Presbyterian Church Men's League. In 2003, it was removed from in front of the post office, but it was returned to its original location in 2008 thanks to funds raised from private individuals and organizations.

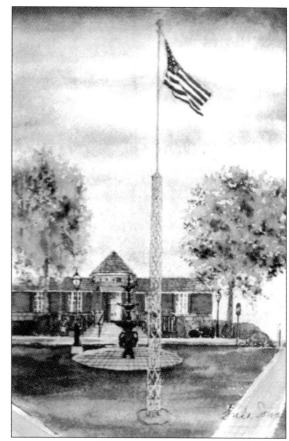

WORLD TRADE CENTER 9/11 MEMORIAL, 2003. Cranford's memorial to those killed in the World Trade Center attack was dedicated on September 11, 2003, at Crane Park on North Union Avenue. The six columns in a semicircle represent the six Cranford residents who died that day. (Courtesy of Jim Occi.)

OLD PEPPY, 2007. Old Peppy was designated the official tree of Cranford in 1964, and its likeness often appeared on Cranford memorabilia. The *Nyssa sylvatica*, also known as a pepperidge tree, sour gum, or black gum, stood on Lincoln Avenue at the edge of Lincoln Park. At over 80 feet tall and at least as wide in its prime, it was believed to be one of the largest of its species in the northeast United States. In 2010, the tree split during a heavy storm, and it was considered a danger, so for safety reasons, it was trimmed severely. It was taken down by the township in 2015, and an analysis of the rings showed it was over 250 years old. Numerous saplings have appeared where the tree stood, and a section of the tree can be seen nearby in a gazebo in the park. (Courtesy of Jim Occi.)

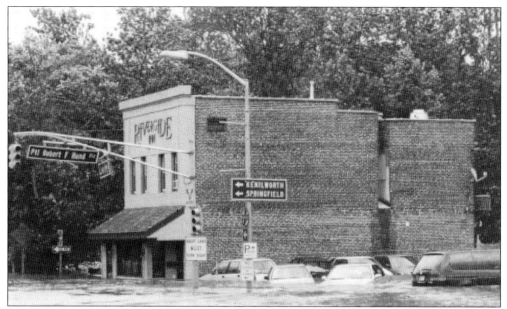

HURRICANE IRENE, 2011. Cranford suffered over $40 million in damages from Hurricane Irene on the days surrounding August 28, 2011. More than 15 percent of houses in town bore significant flood losses, and tons of ruined goods were hauled away. The police station, first aid squad, a school, and numerous businesses, including the Riverside Inn, were under water, as was the PSE&G substation, causing 6,000 residents to lose power. (Courtesy of Jim Occi.)

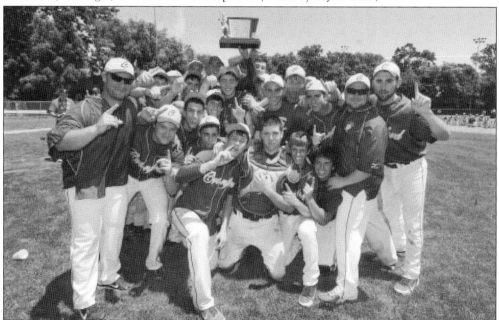

STATE BASEBALL CHAMPIONS, 2012. In 2012, the Cranford High School Cougars hoisted their trophy to celebrate their Group 3 state baseball title after a win over Freehold. The team had a record that year of 22 wins and four losses under coach Dennis McCaffrey. The Cranford High School baseball team was Group 3 state champion in 1971, 1997, 2010, 2012, and 2013. (Courtesy of Jim Occi.)

PLEIN AIR PAINTING EVENT, 2012. At the plein air painting event sponsored by the Jersey Central Art Studios in June, the public had the opportunity to interact with over 30 artists as they painted local scenes. A quick draw also took place downtown for amateurs as well as professional artists. (Courtesy of Deb Leber.)

RUBBER DUCKY DERBY, 2017. The annual Rubber Ducky Derby, held since 2010, starts at Sperry Park, and over 1,500 ducks float down the Rahway River to the North Union Avenue bridge. Proceeds from the purchase of the rubber ducks benefit Hanson Park programs. In 2017, Buddy Valastro, star of *Cake Boss*, was part of the event with this giant yellow rubber duck cake. (Courtesy of William C. King.)

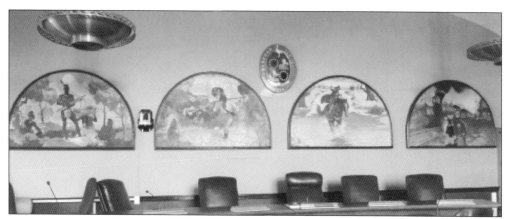

CRANFORD MURALS, 2012. Painted by Cranford artist Everett Ward around 1935, the four-foot-by-six-foot panels depict Lenape Indians, the arrival of European settlers, a Revolutionary War rider at Crane's Mills, and a Victorian steam locomotive. Originally hanging in Cranford High School, they were taken down in the early 1970s and rediscovered in 2008. They were restored and reinstalled in the Municipal Building. (Courtesy of Deb Leber.)

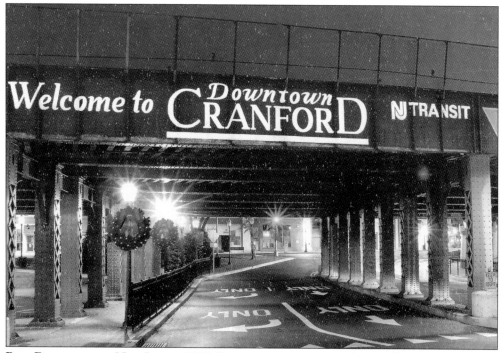

BEST DOWNTOWN IN NEW JERSEY, 2019. For two years in a row, in 2018 and 2019, Cranford was voted the winner of nj.com's "Best Downtown in New Jersey." In 2019, about 85,000 votes were cast for downtowns across the state, and Cranford won over four other finalists, with about 35 percent of the vote. (Courtesy of Downtown Management Corporation.)

CRANSTOCK SUMMER WING, 2019. Cranstock, held each year on the Saturday closest to the summer solstice, was started in 2003 as a way to celebrate friendship. The party, held in Nomahegan Park, includes food, bands, and games and has become a family event. The banner pictured is from 2019. (Courtesy of William C. King.)

PORCHFEST, 2020. Cranford held its fourth Porchfest in October 2020, attracting people from Cranford and nearby towns to hear mostly New Jersey bands play all types of music. Groups performed on the porches of 10 homes around town as individuals, families, and small groups watched from lawn chairs or sitting on the grass or the curb. (Courtesy of Cranford Community Connection.)

GAZEBO, 2021. The Victorian-style gazebo across from the Municipal Building on Springfield Avenue was dedicated in June 1996 as part of Cranford's 125th-anniversary celebration. It has become a landmark and the scene of visits from Santa, concerts, and other township occasions. In 2021, it was adorned with handmade hearts as part of a fundraiser. (Courtesy of Stefanie Lalor.)

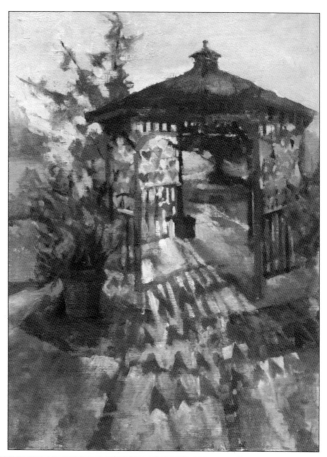

CRANFORD MOVIE THEATER, 2019. In 1926, the Branford Theater opened on North Avenue, and two months later, it changed the B to a C, making it the Cranford Theater. After years of showing movies, the theater closed in September 2019, but it was reopened in November 2019. During the 2020 pandemic, the theater operated as a drive-in at the Orange Avenue pool. (Courtesy of Kevin Papa.)

CRANFORD'S 150TH ANNIVERSARY, 2021. In 2021, Cranford will have been incorporated as a town for 150 years. Activities are planned, but because of the COVID-19 pandemic, they have had to be scaled back and will probably not be like the celebrations of past milestones. The logo that has been chosen to commemorate Cranford's sesquicentennial is in the traditional blue and gold colors of Cranford and includes a crane for the Crane family and Cranford's motto of "Friendship and Progress." Cranford has changed dramatically since it was referred to as Crane's Mills in 1780 in Brig. Gen. William Irvine's letter to George Washington or Craneville, as railroad timetables called it in the late 19th century. Many people, some with recognizable names and some who have been lost to history, have contributed to the town as it is today. However the 150th anniversary is celebrated, Cranford residents salute and thank those who have gone before. (Courtesy of the Township of Cranford.)

Seven

CELEBRATING CRANFORD'S NEIGHBORHOODS 1888–1958

As Cranford's population grew, doubling every 20 years from 1900 to 1960, housing kept pace. Through the years, developers such as Albert Eastman, Miln Dayton, Alden Bigelow, J. Walter Thompson, E.C. Winkler, Shaheen Shaheen, Severin Droescher, T.V. Albert, and Sears, Roebuck & Co. saw opportunity in Cranford.

Even before Cranford was incorporated, the firm of Eastman, Bigelow & Dayton built houses between the railroad and the Rahway River but didn't give their new area a name.

Before the turn of the century, J. Walter Thompson began developing Roosevelt Manor, and E.C. Winkler began Fairview Manor and Prospect Park in the same area.

To meet the financing needs of home buyers, the Cranford Mutual Building and Loan Association was established in 1887. Early in the 1900s, the Aeolian Company built Aeolian Park for its employees near West End Avenue. Between 1908 and 1911, at least seven developments were announced, including Balmiere Park. Lincoln Park, conceived by Severin Droescher, was underway around 1912. By 1918, Shaheen Shaheen was well on his way to building more than 200 homes, including Lehigh Park.

The Depression slowed development, but afterwards, home building got started again, in part due to mortgages guaranteed by the Federal Housing Administration. Immediately before, during, and after World War II, hundreds of homes were built. The breakup of the Osceola Farm on the south side of town created Osceola Park and Sears, Roebuck's Sunny Acres. In 1939, T.V. Albert announced plans for Heathermede Hills at the end of Orchard Street.

Apartment houses were built, including English Village in 1939, Parkway Village in 1947, and Riverside Apartments in 1949. Cranford Crossing and the Riverfront at Cranford Station were added since 2004.

Post–World War II, College Estates was built, as was Canterbury Oaks in the northwest corner of town.

After the 1960s, very little open land was available for building the houses that would make up a named new development. Neighborhoods that been created for marketing purposes were no longer being built, and the older ones were sometimes forgotten.

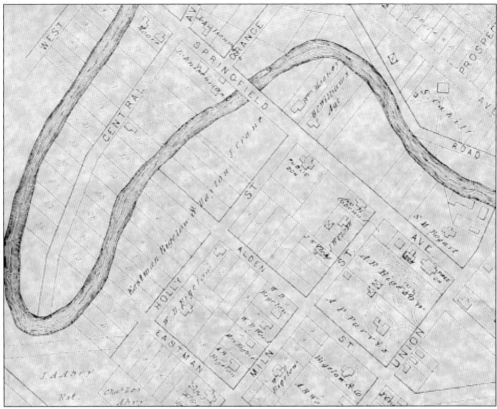

EASTMAN, BIGELOW & DAYTON, 1888. The owners of Eastman, Bigelow & Dayton were New York importers of dry goods in 1865 when they came to Cranford looking for opportunities in real estate. Albert Eastman, Alden Bigelow, and Miln Dayton bought and developed land next to the Rahway River. They named streets after themselves and used the nickname of Alden Bigelow's brother Theophilus to name Holly Street. Alden Bigelow became one of the town's most influential individuals.

HOLLY STREET, C. 1904. Most of the houses on Holly Street were built around 1890 and typify the town's Victorian architecture. In 1966, the Board of Education proposed demolishing eight houses on the river side of Holly Street around Alden Street to build a new primary school. The Homeowner's Protective Association, chaired by Dr. Thomas Dooley who lived on Holly Street, opposed the proposal and prevailed in saving the homes.

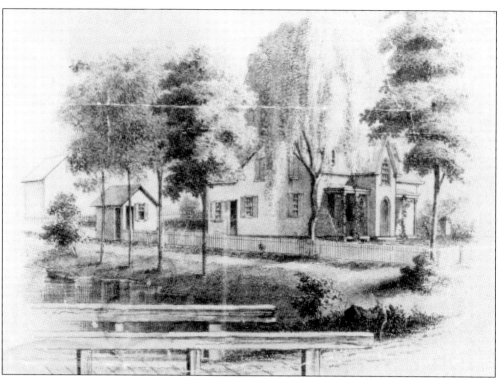

**PHINEAS P. LOUNSBERRY HOUSE,
C. 1871.** Dr. Phineas Lounsberry,
sometimes spelled Lounsbury or
Loundsbury, owned a home on what
would become Central Avenue close
to Springfield Avenue. He was the
inventor of Dr. Lounsberry's Malt
Extract patent medicine, which was
distilled behind the Hansel house on
Springfield Avenue. Like many patent
medicines, the major ingredient was
alcohol, and it reportedly tasted like ale.

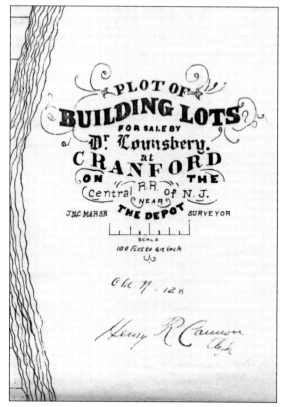

LOUNSBERRY'S BUILDING LOTS, 1874.
In 1866, Dr. Phineas P. Lounsberry
purchased part of the Evert Pierson
property within the horseshoe of
the Rahway River and on the east
side of Springfield Avenue. In 1874,
he subdivided it into lots on what
he named Central Avenue and
advertised them for sale on a peninsula
where until recently cattle had
grazed and apple trees had grown.

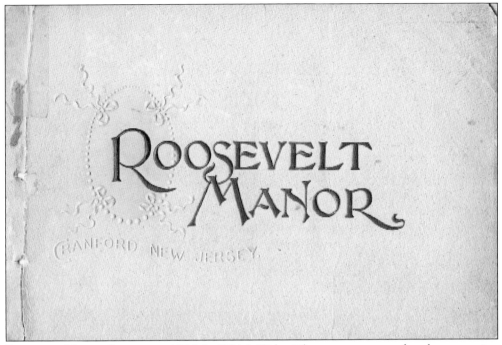

ROOSEVELT MANOR BROCHURE, 1894. In 1894, J. Walter Thompson, creator of modern magazine advertising, appointed his employee James D. Rodgers to manage his new development, Roosevelt Manor. This 32-page promotional brochure included photographs and descriptions of bucolic Cranford, the town's social advantages, and some of the streets in Roosevelt Manor. The brochure offered a number of house designs that could be built for prices from $3,750 to $6,500.

ROOSEVELT MANOR STREET, 1915. Prospect Avenue was the location of some of the finest homes in Roosevelt Manor. In 1905, the street was paved at the expense of homeowners. Seen from the corner of Claremont Place, the house on the right was originally built by F.W. Hunter in 1897. It was owned by E.G. Woodling when this photograph was taken.

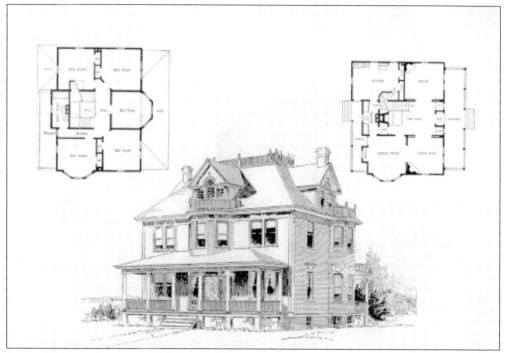

FRANK T. LENT DESIGNS, 1894. Four of the designs in the Roosevelt Manor brochure were by architect Frank T. Lent, who designed many of Cranford's stately homes and public buildings, including the Opera House Block and the first Cranford Casino. Born in 1855, he graduated from Rutgers College in 1878 and lived in Cranford in the 1890s.

ROOSEVELT MANOR MAP, 1894. This map, which was included in the Roosevelt Manor promotional brochure, shows the development bounded by Orange Avenue, Willow (now Manor) Avenue, North Union Avenue, and Riverside Avenue (now Drive). The Cranford Casino is on Riverside Avenue at Casino Avenue, shown with tennis courts behind the building. Houses already existed on 13 of the 150 lots.

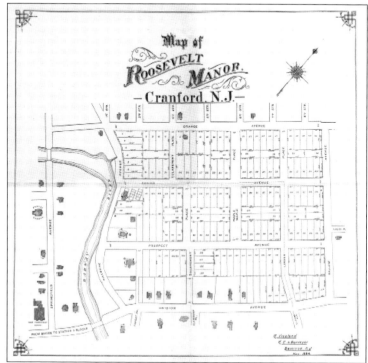

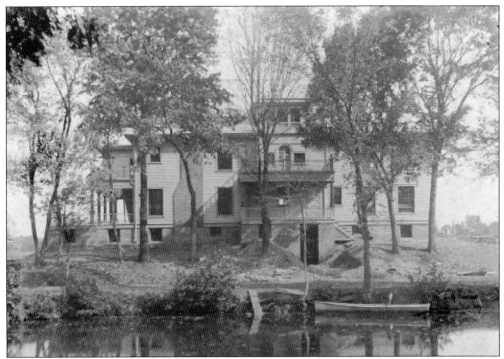

FIRST CRANFORD CASINO, 1892. Cranford's first casino, shown here during construction in 1892, was built at Riverside and Casino Avenues as a members-only country club. There was no gambling or alcohol allowed, and activities included dances, concerts, and bowling and card tournaments. Two tennis courts were next to the building. The first Cranford Casino burned down on January 26, 1897.

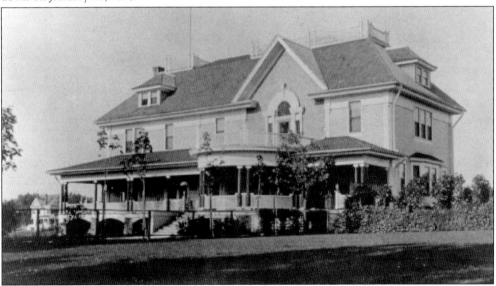

SECOND CRANFORD CASINO, 1899. In 1898, a second casino replaced the first one on the same site. Still a private club, the new building was larger than the first and was the site of parties, dancing lessons for Cranford's youth, bowling alleys, and a billiard room. It was opened to the general public in 1932 then purchased by the American Legion in 1934. It was razed in 1969.

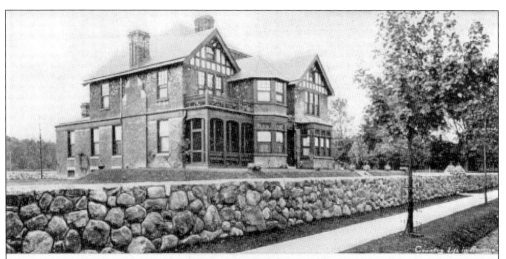

AN IDEAL COUNTRY HOME AT CRANFORD, NEW JERSEY

Forty-five minutes from New York and a few minutes from the station, this unusual house is offered for sale. Grounds 300 x 150 attractively laid out with 3,000 hardy plants and shrubs and tilford drive, the garden is the wonder of the neighborhood. The house 48 x 50 feet thoroughly well built, copper leaders, etc., not an inch of tin being used. Billiard, den, and the usual living rooms, 5 bedchambers. Open fireplace or gas log in every room. Running water, two baths, electric light, hot water heater, all conveniences. Few places have been so carefully planned and built so thoroughly as this.

Full particulars and terms sent on application to

EUSTACE B. POWER - (Owner), - 198 BROADWAY, NEW YORK

STONEHEDGE, 1905. Stonehedge was built on Hampton Street in 1903 for Eustace Power. The house had several owners, and over time, a large glass room was added but then removed. In the 1950s, it was the Southern Club, a residence for well-educated young men who worked in the area. It is again a private home, surrounded by its original stone wall. (Courtesy of Nancy and Stephen Price.)

Cranford Heights

THE FINEST BUILDING SITES IN TOWN.

FRONTAGES ON FOUR STREETS—NORTH AVENUE, HAMILTON AVENUE, ELIZABETH AVENUE, JOHN STREET.

Forty-five full size lots, with restrictions that insure the character of the neighborhood.

All within eight minutes walk of Central station, and Westfield Avenue trolley.

SEWERS, LIGHTS, WATER, SIDEWALKS AND EVERY OTHER IMPROVEMENT MADE, OR ARRANGED FOR, AND VALUES ARE SURE TO INCREASE IN THE IMMEDIATE FUTURE.

Houses built to suit purchaser and sold on easy terms.

Inspection is invited, and inquiries regarding this fine property may be made of the owners.

RUTH & CO.,

Miller Block, - Cranford.

CRANFORD HEIGHTS, 1906. Developers frequently advertised the advantages of their building sites. This advertisement appeared in the 1906 *Cranford Directory*, an annual guide to people and businesses. Cranford Heights was one square block of 45 lots developed around Elizabeth Avenue. Another development announced in 1909 on Walnut Avenue south of the Lehigh Railroad was also called Cranford Heights.

JOSEPH HUNTER DICKINSON, C. 1885. Joseph Hunter Dickinson, born in 1855, held 33 patents for organs, pianos, and phonographs, 19 of which were filed while he was with the Aeolian Company of Garwood. He lived in Cranford from 1902 to 1920 on Pianola Avenue in Aeolian Park, a development created by Aeolian for its workers. He was listed in several books about notable African Americans and died in 1936. (Courtesy of Jean Kreiling.)

AEOLIAN PARK, 1908. In 1901, the Aeolian Company purchased an area bordered by Orchard and Willow Streets, West End Place, and what would become Torbush Street and built several houses for its workers. The streets it created were named after the company and its products: Pianola, Aeolian, and Ariola Avenues. Pianola later became Beech Street, and Aeolian became Spruce Street. Cranford High School was built over Ariola Avenue.

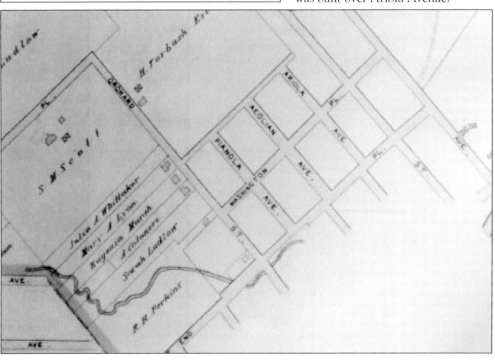

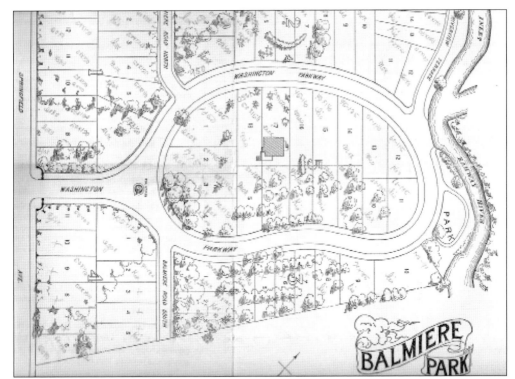

BALMIERE PARK, 1909. Balmiere Park was built between the Damon and Doering properties off Springfield Avenue by Cranford Homes Company in 1909. The company assured buyers that it was a builder, not a land boomer, and sold all 68 available lots for over $50,000 at a one-day auction. Advertisements promised to establish a central heating and hot water plant and a central laundry and drying room.

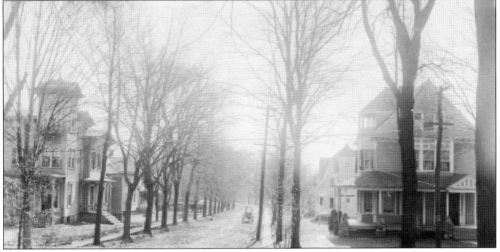

MARLBOROUGH STREET, 1912. Before 1918, Springfield Avenue ended at North Union Avenue, and the one-block Marlborough Street linked North Union and North Avenues. In 1917, a house was removed, a short segment of road was added, and most of Marlborough Street became a continuation of Springfield Avenue. A small section of Marlborough Street that was left was purchased by the town in 1925 and is now the site of the gazebo.

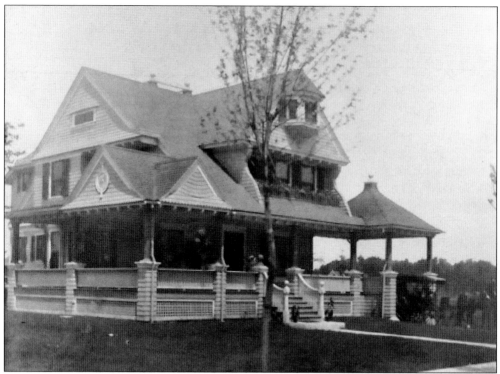

THOMAS SPERRY'S FIRST HOUSE, C. 1901. Thomas Sperry's first house, built in 1894, still stands on North Union Avenue. He and his wife, Kate Major Sperry, were at the top of Cranford's society at the turn of the century. As his fortunes increased, in 1902, he built a larger mansion a few blocks away on Prospect Avenue.

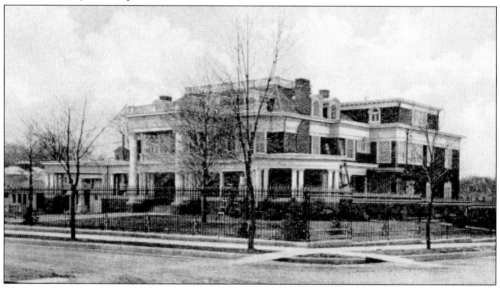

THOMAS SPERRY'S THIRD HOUSE, 1915. Thomas Sperry built a home at Prospect Avenue and Claremont Place in 1902. That home was substantially destroyed by a fire in June 1912, and this home soon replaced it. The newer house was demolished in 1938, and English Village Condominiums was built on the site. The original Sperry iron fence and the stone sunken garden still exist.

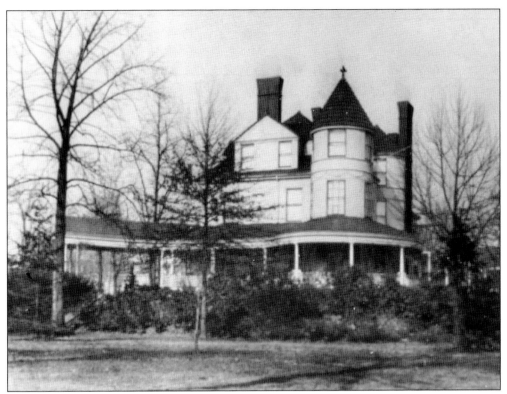

WILLIAM M. SPERRY'S HOUSE, 1910. William Sperry lived in this house from 1907 until his death in 1927. It stood at the site of what is now the Riverside Condominiums on Riverside Drive and North Union Avenue. He founded the Cranford National Bank, built the Sperry Building on North Avenue, and was associated with his brother Thomas in the S&H Green Stamps company.

S&H GREEN STAMPS, 1907. Thomas Sperry, along with Shelly Hutchinson, founded the Sperry & Hutchinson Company, creator of S&H Green Stamps, in 1896. S&H became one of the first independent trading stamp companies and gained popularity during the early 1900s, since the S&H plan offered incentives to shoppers rewarding them for making timely cash payments and helped maintain customer loyalty to merchants that participated in the program.

GREEN TRADING STAMP "Premiums"

FOR more than a Decade, "S. & H." Green Trading Stamps have supplied hundreds of thousands of families with comforts they would not have had but for "S. & H." Stamps.

Thousands of other families, while able to buy anything they need, candidly appreciate the many benefits they have obtained through "S. & H." Stamps.

None of these families have spent one cent more than they would have spent; they have spent less, for the merchants who give "S. & H." Stamps almost invariably sell better goods and at lower prices than those who do not give stamps.

Every "S. & H." Stamp you get is clear gain—actual money—as the Premiums (consisting of nearly everything) would cost you money unless obtained for

"S. & H." GREEN TRADING STAMPS

Original, International, Everlasting.

We Will Give You Stamps For Your Coupons, Labels, Etc
Send two cent stamp for particulars and illustrated catalog of "Premiums"

The Sperry & Hutchinson Co., Prop.

THOS. A. SPERRY, Prest. Paid-up Capital $1,000,000

HOME OFFICE, 320 BROADWAY, NEW YORK

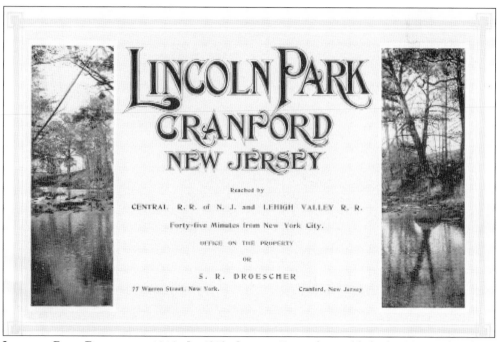

LINCOLN PARK BROCHURE, 1912. In 1912, Severin Droescher published a 32-page brochure advertising Lincoln Park, an area he planned to develop around Centennial Avenue from South Avenue to Lincoln Avenue. He frequently advertised in local and New York newspapers, announcing paved streets, sidewalks, electric lamps, a sewer system, and water service. He stressed the easy commute to New York City. For reasons unknown, the development never saw its full potential.

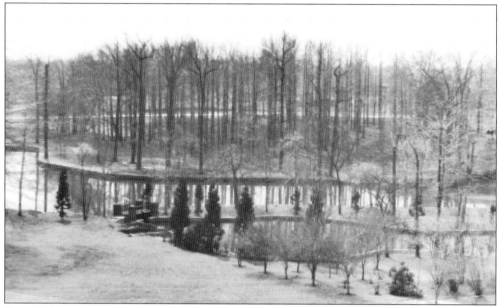

LINCOLN PARK POND AND BRIDGE, 1918. Advertisements emphasized Lincoln Park's bucolic setting bordering the Rahway River and featuring a private park, a boat landing, a bridge to an island, a skating pond, and two dams to broaden the stream. Remnants of those features can still be seen, like the pillars for the bridge near the skating pond along the riverwalk near Droescher's Mill.

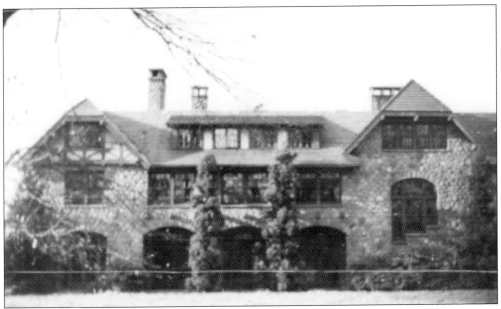

GREYSTONE, 1921. Built by Charles Kaltenbach in 1920 on Lincoln Park lots, Greystone featured 14 acres of beautifully landscaped gardens fronting on the river. Charles Kaltenbach was president of Kaltenbach and Stephens Silk Ribbon Company, the world's largest manufacturer of narrow silk ribbons. The estate experienced financial difficulties, and after Charles Kaltenbach's death, the township acquired it around 1938. It was later sold and is now a rehabilitation center.

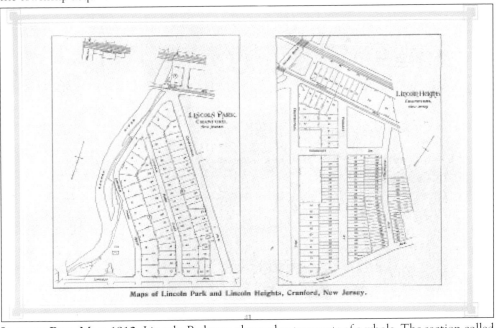

LINCOLN PARK MAP, 1912. Lincoln Park was planned as two parts of a whole. The section called Lincoln Park was on the west side of Centennial Avenue and had 68 large lots. Lincoln Heights, on the other side of Centennial Avenue, included Thomas Street and Burchfield Avenue and had 147 smaller lots. The first foundations were laid in July 1913, but by 1922, only 24 houses had been built.

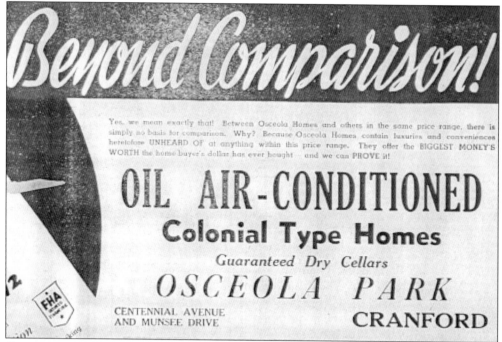

Beyond Comparison!

Yes, we mean exactly that! Between Osceola Homes and others in the same price range, there is simply no basis for comparison. Why? Because Osceola Homes contain luxuries and conveniences heretofore UNHEARD OF at anything within this price range. They offer the BIGGEST MONEY'S WORTH the home buyer's dollar has ever bought—and we can PROVE it!

OIL AIR-CONDITIONED
Colonial Type Homes
Guaranteed Dry Cellars
OSCEOLA PARK

CENTENNIAL AVENUE
AND MUNSEE DRIVE

CRANFORD

OSCEOLA PARK, 1937. Osceola Park was built by Thomas Sperry Jr. on what was once part of the Sperry family's Osceola Farm. The first houses opened in 1939 and were advertised with air-conditioning, which meant a forced-air oil furnace. There were plans to construct 200 homes, but only 67 of the houses around the newly created Munsee Drive between the Rahway River and Centennial Avenue were completed before World War II.

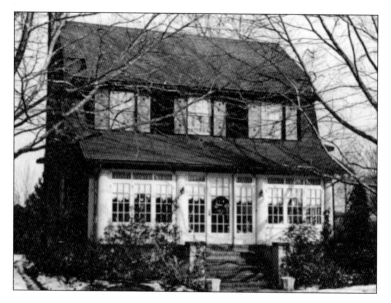

BURCHFIELD AVENUE, 1946. Construction began on houses in the area once known as Severin Droescher's Lincoln Heights around 1916. This Dutch Colonial house on Burchfield Avenue was built in 1920, and J. Edward Wolf was the first owner. Edward Wolf served on the township committee from 1934 to 1951 and was police commissioner for 15 years.

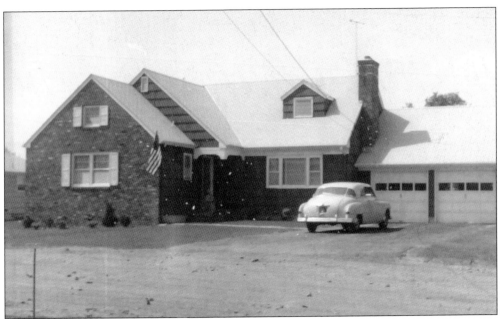

COLLEGE ESTATES, 1958.
Streets in the College Estates neighborhood were named after educational institutions in the Northeast like Harvard, Cornell, Brown, Dartmouth, and Rutgers. Harvard Road is seen here before roads were paved. The area was built in the late 1950s next to what is now Union County College in the northern section of Cranford as housing moved farther from the center of town.

BYRNES BUILDING COMPANY, 1913. An advertisement for Byrnes Building Company appeared in a 1913 Cranford Board of Trade booklet detailing the advantages of living in Cranford. The Byrnes Company, located in nearby Elizabeth, was established in 1897 and built many houses and public buildings in the area. The advertisement pictured the Cranford Trust Building, Osceola Farm, and Thomas Sperry's house. Byrnes also built the first public library on Miln Street.

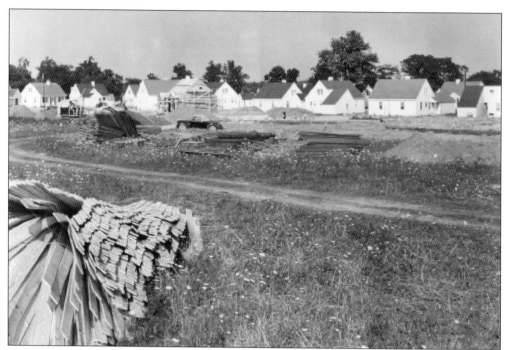

SUNNY ACRES CONSTRUCTION, 1941. Sunny Acres represented a new approach by Sears, Roebuck & Co., which had begun selling kit homes in 1907. In Cranford, Sears Modern Homes Division bought the land, built the houses, and offered them for sale. The houses in Sunny Acres were built in three phases between 1940 and 1943. Pictured is the construction of Oneida Place and Algonquin Drive. (Courtesy of the Sunny Acres Civic Association.)

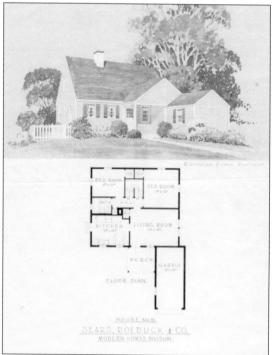

SUNNY ACRES MODEL HOUSE PLAN, 1940. Houses in Sunny Acres, a development of 172 homes between the Rahway River and Raritan Road, were mostly Cape Cod style, but to avoid a cookie cutter appearance, the architects rotated the floor plan and put the garage in a different position, giving each house a different look. Sample floor plans such as these were used to market the houses. (Courtesy of the Sunny Acres Civic Association.)

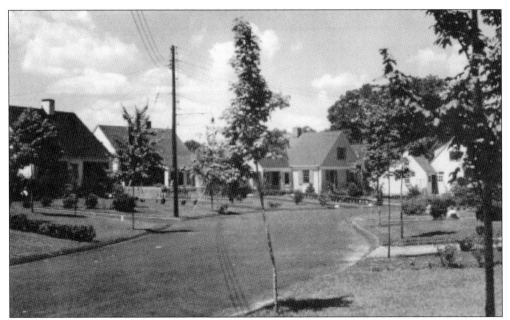

SUNNY ACRES STREET, 1941. Since it was built on land that was once Thomas Sperry's Osceola Farm, Sunny Acres was a wide-open tract, a fact subtly reflected in the name chosen for the development in a contest sponsored by Sears. Trees were planted as the development progressed. Sunny Acres was designated a Cranford historic district in 2018. (Courtesy of the Sunny Acres Civic Association.)

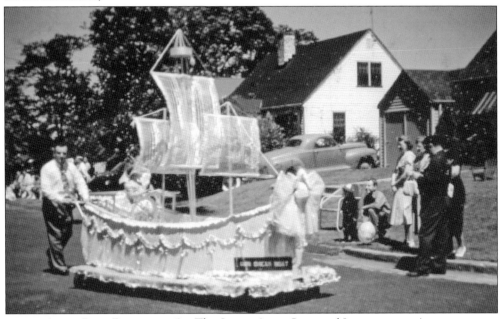

SUNNY ACRES BABY PARADE, 1950. The Sunny Acres Civic and Improvement Association was formed to advocate for the growing development and later evolved into a more socially oriented organization. One of its many sponsored events was the annual Baby Parade, held from 1944 to 1960. The "Our Dream Boat" float, featuring four-year-old Barbara Barta, won first prize in 1950 in the large float division. (Courtesy of the Sunny Acres Civic Association.)

CRANFORD, 1913. The souvenir programs for the Cranford river carnivals held in 1914 and 1916 could be purchased for 10¢. Each had a wraparound cover featuring a tree with lanterns hanging from its branches and listed the officers of the Cranford Carnival Association, the canoe and float entries, and prizes that would be awarded. Inside that wrap was a 64-page promotional booklet about Cranford with a cover showing a man and a woman in a canoe on the Rahway River. The booklet, entitled *Cranford*, was published in 1913 by the Cranford Board of Trade, and it described why Cranford was "the ideal all-year-round residence town." It elaborated on the many benefits of living in Cranford, describing the climate, schools, transportation, businesses, and clubs. Photographs of houses, streets, public buildings, and of course the Rahway River filled every page. The last pages featured advertisements for building lots and builders that were ready to develop Cranford's neighborhoods.

Eight

CELEBRATING CRANFORD'S WOMEN 1850–2020

Fannie Bates, Elizabeth Miller Bates, Alice Lakey, Deborah Wolfe, and innumerable other women had a profound impact on Cranford, and some on the nation as well. Their efforts led to better quality of life, purer food, and women's right to vote.

A major force in Cranford's development was the Village Improvement Association (VIA), established in 1896 by Fannie Bates, owner of Hampton Hall. The members of the VIA saw what needed to be done and did it, sometimes over the objections of the men of the town. Among other things, they arranged for the removal of garbage and ashes, worked on school issues, and created a hospital fund for the poor.

Alice Lakey was a consumer protection crusader before it was fashionable. She worked to pass the Pure Food and Drug Act in 1906. She was also instrumental in many local improvements as president of the VIA.

Elizabeth Miller Bates was one of the representatives at a hearing on suffrage in Trenton. In 1913, she marched in a suffrage parade in Newark. She was also one of the first women to serve on the Union County grand jury in 1922.

In addition to all the women teachers who have taught Cranford children over the years, Sarah Edmond stands out as the first woman supervising principal of the public schools.

Women have long been in public service, more recently in more visible roles. In the 1970s, Barbara Brande was the first woman to be elected to the township committee and the first woman mayor. Vanessa Van Brunt was the first woman member of the police department in 1993.

Women's clubs have been important in Cranford's social, cultural, and civic life. They started in 1891 with the organization of the Wednesday Morning Club, whose subscription library became the Cranford Public Library. Through the years, the women in clubs such as the College Women's Club, the Newcomers Club, the Junior Women's Club, and numerous garden clubs have contributed to the intellectual and physical wellbeing of all of Cranford's citizens.

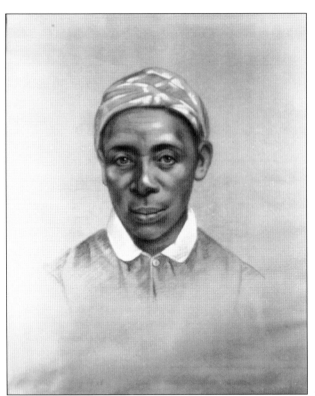

SARAH, C. 1850. The Denman family arrived in Cranford about 1720 and owned a large tract of land south of what is now Lincoln Avenue. Sarah was associated with the Denmans, and whether she was a free or enslaved servant is not clear. In New Jersey, some enslaved people were held as late as 1865, but at the same time, the 1860 census reported 25,318 free Blacks in the state.

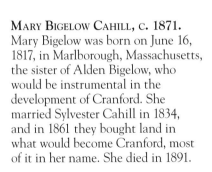

MARY BIGELOW CAHILL, C. 1871. Mary Bigelow was born on June 16, 1817, in Marlborough, Massachusetts, the sister of Alden Bigelow, who would be instrumental in the development of Cranford. She married Sylvester Cahill in 1834, and in 1861 they bought land in what would become Cranford, most of it in her name. She died in 1891.

ISABELLA WILLIAMS CRANE, c. 1875. Isabella Williams was a member of the family who owned the Williams' or Vreeland's Mill. She lived on the mill property with her aunt Elizabeth Williams Vreeland from the age of eight until 1873, when she married Theodore A. Crane, who was Cranford's tax collector from 1894 to 1916. They lived on Walnut Avenue and had three children.

PARMENTIER WOMEN, 1882. Members of the Parmentier family are seen on the porch of their house on Westfield Avenue, now Lincoln Avenue. The Parmentiers owned a large tract of land near South Union and Westfield Avenues, next to the Denman farm.

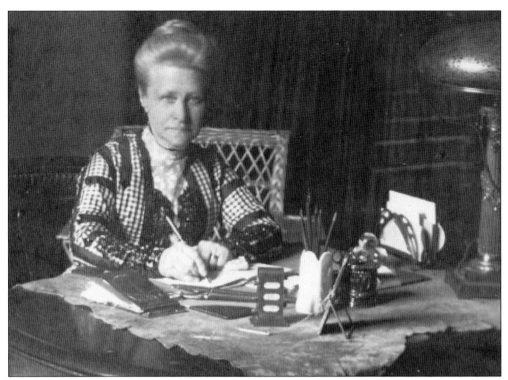

FANNIE BATES AND HAMPTON HALL, 1890. Fannie Bates, known as the "Mother of Cranford," founded the Village Improvement Association (VIA) in 1896 and was its first president. Through the VIA, she led the local women's movement that brought about cleaning the streets, plowing snow, constructing schools, organizing the school board, and closing a brewery and gambling parlor. She also established Hampton Hall in 1892. Designed by Frank T. Lent, it became a fashionable 40-room residence hotel and the site of town events at Hampton and Eastman Streets on the Rahway River. In 1901, Fannie Bates bought a nearby house as an annex and joined the two three-story wooden buildings by an archway. Hampton Hall was sold by her heirs in 1954 and became a boarding home for the elderly. It was demolished in 1969.

SARAH VREELAND, C. 1888. As early as 1850, the Vreelands owned a large tract of land south of what is now Lincoln Avenue near Walnut Avenue, and they later owned at least two mills on the Rahway River. In 1876, some of the property was advertised at a sheriff's sale and was bought by Sarah Vreeland, whose relationship to the other Vreelands is not known.

MARTHA GOODMAN, c. 1892. Martha Goodman was born in Virginia in 1869 and later came to Cranford. She married Walter Goodman in 1890; they were probably already married when they came north. They lived on Bloomingdale Avenue in 1900 but moved to Garden Street sometime before 1910. There is no occupation listed for her in the 1900 US Census, but Walter Goodman is listed as a laborer.

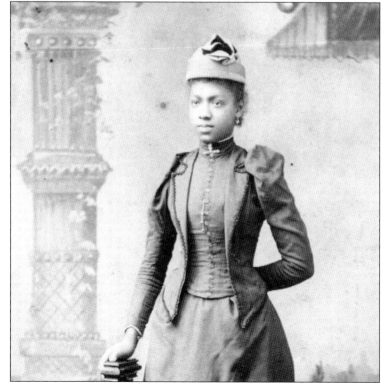

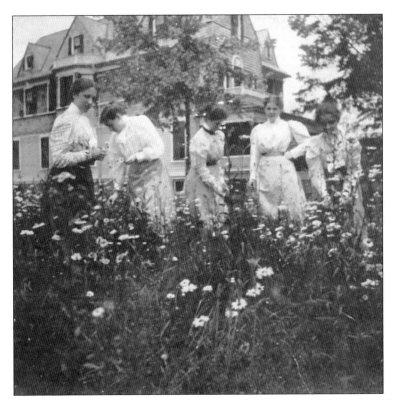

BUCKLEY WOMEN, 1898. Five young women are pictured in the garden behind the Buckley house on Central Avenue. Presumably among them are sisters Anne and Marjorie Buckley. In 1918, Anne Buckley joined the corps of ambulance drivers at the hospital that had been established in Colonia for wounded soldiers returning from World War I.

ELIZABETH MILLER BATES, 1901. Born in 1879, Elizabeth Miller moved to Cranford in 1890, married George Bates in 1901, and so became the daughter-in-law of Cranford's Fannie Bates. She worked for women's suffrage, representing Cranford at the Equal Franchise League hearings in Trenton. She was active with numerous local organizations and during World War I joined the Red Cross, continuing her service there for 50 years. She died in 1980 at age 101.

FLORENCE BRADLEY ROSENCRANTZ, 1903. In 1903, Florence Bradley was awarded a silver loving cup for her victory over Adele Borden, the local favorite, at the Asbury Park Lawn Tennis Club. She lived on Orchard Street and married John Rosencrantz in 1906. Lawn tennis had come to the United States in 1874 and was gaining in popularity.

HORTENSE SMITH BRACKETT, 1909. Hortense Smith reportedly had a beautiful soprano voice and frequently sang at events in Cranford in the early 1900s. Dr. Wilbur Brackett, who had come to Cranford in 1897, was one of the town's dentists, with a practice on Miln Street. They attended many of the same parties at the Cranford Casino, they married about 1910, and soon afterward moved to New York City.

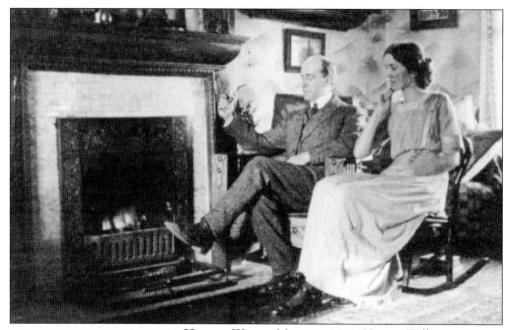

HONORE WILLSIE MORROW, 1911. Honore Willsie Morrow was born Nora Bryant McCue in 1880. She is seen here with her first husband, Henry Willsie, in their home on Berkeley Place, where she lived for five years. She published meticulously researched historical fiction as well as nonfiction and was the editor of the *Delineator*, a woman's magazine.

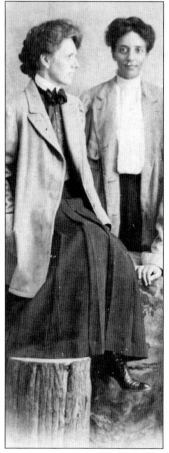

SARAH EDMOND, 1915. Sarah Edmond, who began teaching math in Cranford in 1902, was later appointed principal of the Grant School, then in 1914 supervising principal of all schools. She was a progressive educator and frequently argued with the Board of Education. On her resignation in 1934, her associates presented her with a car. Here Sarah Edmond is on the right, and history teacher Clara Edmond is on the left.

ALICE LAKEY, C. 1918. Alice Lakey was born in 1857, and at the age of 39, she moved to Cranford. She had studied voice in Europe, and she taught music at her home on Miln Street. Because of her father's eating habits, she became interested in food science and health. In 1903, she invited a speaker to Cranford to talk about tainted food, and she became an enthusiastic supporter of national food laws. As head of a national committee, she met with Pres. Theodore Roosevelt and later mobilized over one million women to write letters in support of the Pure Food and Drug Act, which was passed in 1906. In 1909, she influenced the writing of legislation to certify the quality of milk in New Jersey, and that law became the model for other states. She also lectured, wrote, and lobbied extensively for causes like women's suffrage and the importance of life insurance. She was president of the Cranford Village Improvement Association, helped found the local Visiting Nurse Association, and served on the Zoning Commission. She died in 1935.

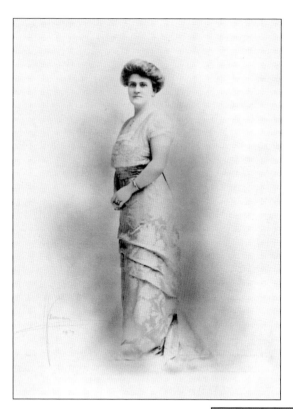

KATE MAJOR SPERRY, 1917. Kate Major married Thomas Sperry, cofounder of S&H Green Stamps, in 1891, and they lived in a mansion at Prospect Avenue and Claremont Place. It was reported that when a fireman saved her wedding portrait from her burning house in 1912, she shouted, "Don't save that. Save something worthwhile." Thomas Sperry died in 1913, and she married Edward Goodrich in 1917.

ALICE CRUMP, C. 1940. Alice Miller Crump, born in 1894, attended school in Washington, DC, where she was active in the suffrage movement, then went to New York, where she met her husband, artist Leslie Crump. They moved to Cranford in 1921 and lived on Central Avenue then on Linden Place. Alice Crump painted portraits and other works at her studio in the post office building at Alden Street and North Union Avenue.

HELEN CEDERHOLM, 1941. Helen Cederholm reads the newspaper in her backyard on Mohican Place in newly established Sunny Acres. In 1941, she won the contest to name Sunny Acres, taking home the prize of $25. She, her husband Oscar Cederholm, and daughter Judy were among the first families to move into the new development. (Courtesy of the Sunny Acres Civic Association.)

MARGARET MUNNINGHAM, 1943. Margaret Munningham of South Union Avenue attained the rank of Women's Army Auxiliary Corps (WAAC) leader, the same as an Army sergeant, during World War II. Seen here on the left, with Sylvia Buttner of New York on the right, she was featured in a front-page *Cranford Chronicle* article in 1943 that said she exemplified that "fighting a war for freedom wasn't a man's job alone."

BARBARA BRANDE, 1977. Barbara Brande was the first woman elected to the township committee and the first woman to serve as mayor. She was elected to the township committee in 1974 and reelected in 1977, becoming mayor that year and serving on the committee a total of six years. She was also a member of the New Jersey delegation to the 1980 Democratic National Convention. (Courtesy of the Township of Cranford.)

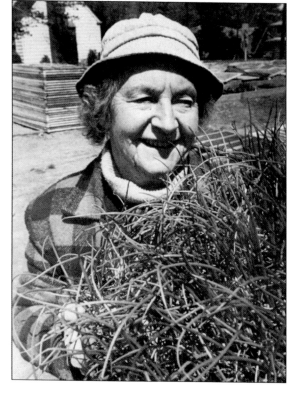

HENRIETTA DREYER, 1986. Henrietta Dreyer, born in 1913, started the Dreyer Farms produce and plant stand on Springfield Avenue in 1946, running and expanding it while her husband, Henry Dreyer, grew the vegetables. She held offices in several agricultural organizations, including serving as president of the Union County Board of Agriculture. Established in 1904, Dreyer's is the only working farm still operating in Union County. (Courtesy of the Dreyer family.)

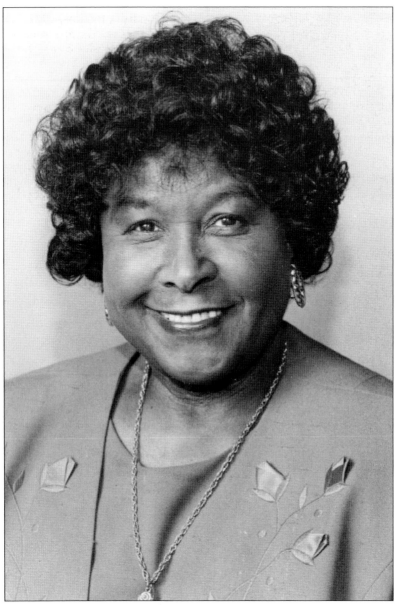

DEBORAH CANNON PARTRIDGE WOLFE, 1985. Deborah Cannon Partridge Wolfe was born in Cranford in 1916 and lived on South Union Avenue. After graduating from Cranford High School in 1933, she earned a bachelor's degree from New Jersey State Teachers College and a master's and doctorate from Columbia University. She wrote and lectured and served on numerous boards, committees, and organizations in the fields of education, women's rights, and Black causes. She was on the faculty of the Tuskegee Institute and Queens College. She also held the post of education chief of the Congressional Committee on Education and Labor, where she worked to create Head Start and improve educational accessibility. She was the first African American woman ordained by the American Baptist Church and, starting in 1975, served as the associate minister of the First Baptist Church in Cranford, where her father had been pastor. Locally, she has been honored by the dedication of the Cranford High School library in 2020 and on a Union County Heritage Across the Centuries card. (Courtesy of the Deborah Partridge Wolfe family.)

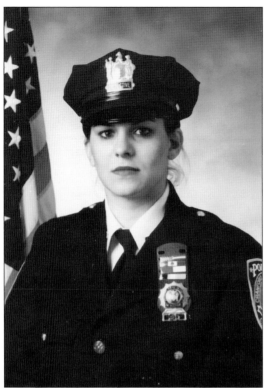

VANESSA VAN BRUNT, 1993. Vanessa Van Brunt graduated from Cranford High School and in 1993 became Cranford's first woman police officer. She served 10 years doing undercover and narcotics assignments and rose to the rank of detective. She was a first responder at the World Trade Center during 9/11. She then went on to work in financial services and now owns a consulting firm. (Courtesy of Vanessa Van Brunt.)

CAROL BLAZEJOWSKI, 2020. As a student at Cranford High School in 1974, Carol Blazejowski played on the girls' varsity basketball team. She then played at Montclair State University and was a member of the 1980 USA Olympics team, going on to be president of the New York Liberty. She was elected to numerous halls of fame, and the Lincoln Park basketball courts are dedicated to her. (Courtesy of Carol Blazejowski.)

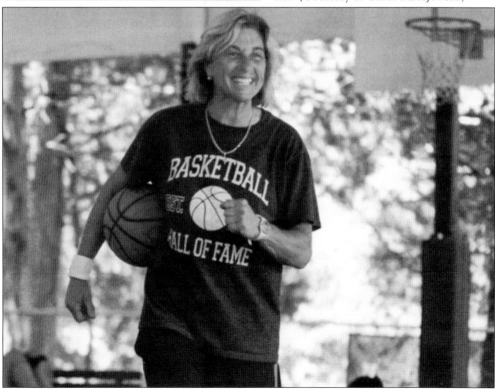

OF INTEREST TO MAID AND MATRON

EDITED BY VIRGINIA SLOANE

ranford, N. J., Ruled by Women Like Its Fiction Prototype

IT WAS THE WOMEN WHO INSISTED ON IMPROVED SCHOOL BUILDINGS

MRS. FANNIE M. BATES WHO IS CALLED THE MOTHER OF CRANFORD

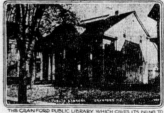

THE CRANFORD PUBLIC LIBRARY WHICH OWES ITS BEING TO THE WOMEN OF THE VILLAGE

SAN FRANCISCO CALL, 1912. The September 29, 1912, issue of the *San Francisco Call* included an article entitled "Cranford, N.J., Ruled by Women Like Its Fiction Prototype." It compared the women of our New Jersey town to those in a popular English novel entitled *Cranford*, published in 1853 by Elizabeth Gaskell. The novel was a series of unrelated sketches about a small English town predominantly inhabited and run by women. The unnamed author of the article believed that our New Jersey women ruled as well, if not better, than their fictional counterparts, by urging or sometimes forcing the men of the town to make needed improvements, and if that didn't work, instituting changes themselves. The author detailed the establishment of the Wednesday Morning Club and the Village Improvement Association and gave examples of the progress the women of Cranford, New Jersey, made in the town through determination and ingenuity. (Courtesy of the Library of Congress.)

127

DISCOVER THOUSANDS OF LOCAL HISTORY BOOKS
FEATURING MILLIONS OF VINTAGE IMAGES

Arcadia Publishing, the leading local history publisher in the United States, is committed to making history accessible and meaningful through publishing books that celebrate and preserve the heritage of America's people and places.

Find more books like this at
www.arcadiapublishing.com

Search for your hometown history, your old stomping grounds, and even your favorite sports team.

Consistent with our mission to preserve history on a local level, this book was printed in South Carolina on American-made paper and manufactured entirely in the United States. Products carrying the accredited Forest Stewardship Council (FSC) label are printed on 100 percent FSC-certified paper.

MADE IN THE USA